IMAGES
of America

BOSSIER PARISH

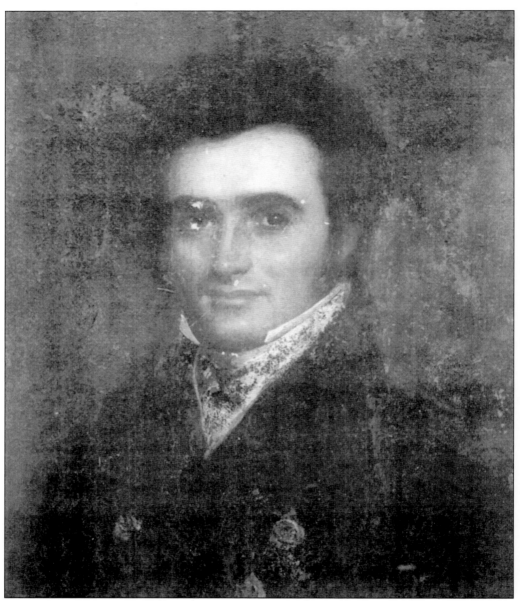

General Pierre Evariste Jean Baptiste Bossier (1797–1844) was the most prominent of the Bossier family after which the parish of Bossier was named. A resident of Natchitoches, Louisiana, he was a general in the Second Louisiana State Militia, a ten-year veteran of the state senate and a representative of Louisiana in the United States capitol. Pierre Bossier was the fifth generation of French-Creole descent to live in Louisiana. His great-great-grandfather, Jean Baptiste Bossier *dit* Lebrun, came to Louisiana with Bernard LaHarpe in 1720. His uncle, Placide Bossier, had signed the first Louisiana constitution in 1811 and was the first to represent Natchitoches in the state senate. Pierre's first cousin, General Jean Baptiste Bossier, lived in St. Genevive, Missouri, and was also well known in New Orleans and along the Mississippi River. With all his stately accomplishments, Pierre Bossier was most famous for his successful duel to the death with General Francois Gaiennie, in 1839.

2

IMAGES
of America

BOSSIER PARISH

Clifton D. Cardin

ARCADIA
PUBLISHING

Published by Arcadia Publishing
Charleston, South Carolina

Printed in the United States of America

Library of Congress Catalog Card Number: 99-63305

For all general information contact Arcadia Publishing at:
Telephone 843-853-2070
Fax 843-853-0044
E-Mail sales@arcadiapublishing.com
For customer service and orders:
Toll-Free 1-888-313-2556

Visit us on the Internet at www.arcadiapublishing.com

CONTENTS

To my wife, Debbie, for giving me her extreme patience during the tedious production of this book. Without her there to handle our personal and business affairs, I would not be able to achieve any of the things that I get credit for doing. She makes me look good.

To my son, Jason, the best son a man could have!

INTRODUCTION

As of 1999, Bossier Parish is home to some 98,000 residents. Some are descended from Bossier's earliest settlers and slaves, many have retired here after being stationed at Barksdale Air Force Base, and yet more recently others have come to be employed by the exploding riverboat gaming industry. Despite their diverse social and economic backgrounds, most of them are interested in Bossier's past and have a quest for local historical knowledge.

Bossier Parish was originally settled in the 1830s and 1840s by numerous wealthy plantation-owners, who speculated in land and grew cotton. Plantations of 12,000 acres were not uncommon, and some owners had more than one plantation. With these plantation-owners came the people they employed. Cotton crops and the way of life that made it profitable was the norm for the first 20 to 30 years. In fact, Bossier Parish was one of the fourth richest parishes in Louisiana prior to 1860. But the war between the States brought an almost total destruction to the wealth that financed that lifestyle.

The 1870s were truly a time of reconstruction for Bossier Parish. Not only had the war drained the area's economy, but major flooding shortly after the war decimated the crops. However, the people did survive and prospered to some degree.

By the 1880s and '90s wealth was renewed by the coming of the "iron horse" railroad and the ability to cut and ship massive amounts of timber products to the markets in the north and east. Large towns were created throughout the parish, solely for the purpose of harvesting that cash-crop. Even today, the timber industry is the largest industry in the parish.

The discovery of oil in Bossier in 1908 began its next big boom, financed by the "black gold." From then to the 1980s, Louisiana and Bossier Parish relied heavily on the monies brought by the ever present oil industry. The oil bust of the 1980s ended that free ride. Now Bossier is finding a new-found wealth in its newest form of "green gold"—riverboat gaming. It leads the state, even the nation, in number of gaming boats lining its riverbanks.

Paintings, pictures, and photographs tell a visual story found wanting in most written accounts. They convey the message faster than any well-written novel can do. But, while every effort has been made to make a good sampling of Bossier's historic photographs within this book, there are simply some pictures that are not available.

If a picture is worth a thousand words, then this book is worth a couple of hundred thou'.

One

THE PEOPLE OF BOSSIER

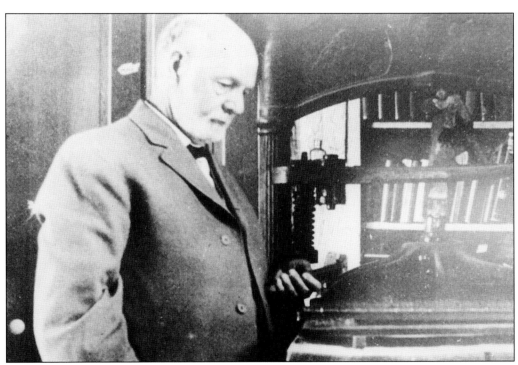

William Henry Scanland is probably the most important Bossier person, in terms of having recorded parish history. He arrived in Bossier in 1857 as a 15-year-old orphan and by the age of 17 had started the *Bossier Banner* newspaper, the oldest weekly newspaper in north Louisiana. He personally witnessed and wrote much of Bossier's history until his death in 1916. His son, Abney Downs Scanland, continued publication of the paper and his father's tradition of printing a local newspaper, and is the source of many of the pictures in this book. The newspaper they published is now the *Bossier Banner-Progress*—a division of the *Bossier Press-Tribune*. The Washington Press in the background still exists, although now a garden centerpiece.

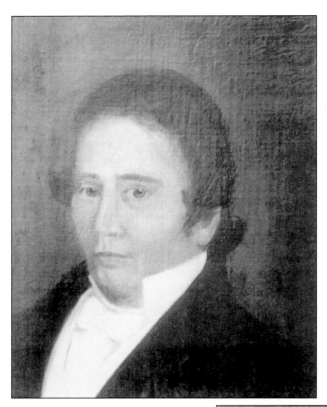

This is General Pierre Bossier as he appeared about the time of his infamous duel with General Francois Gaiennie. On "the field of honor," from 40 paces, on the count of three, they fired rifles. Gaiennie missed, Bossier did not. It is said that Bossier forever regretted killing his childhood friend. Pierre E. Bossier died in Washington, D.C., on April 24, 1844, after a lengthy illness.

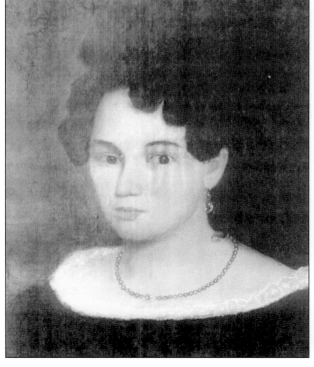

Matilda Blair Bossier, of Pittsburgh, Pennsylvania, was the wife of General Pierre E. Bossier. They married in Natchitoches, Louisiana, on December 23, 1817. They had no children. Upon his death, she pleaded with the courts that the assets of the succession exceeded the debt of the estate. She died in July of 1844, only months after her husband. They are buried side-by-side in the American Cemetery in Natchitoches, Louisiana.

"Cousin" General Jean Baptiste Bossier, of St. Genevive, Missouri, has been wrongly identified by historians for years as our Louisiana General Bossier. This portrait was drawn by the famous ornithologist John James Audubon in New Orleans in 1821, and is of General Jean Baptist Bossier, who lived in Missouri and was a direct cousin to General Pierre Bossier of Natchitoches. This priceless original black chalk drawing now hangs in the Nelson Art Gallery in Kansas City, Missouri.

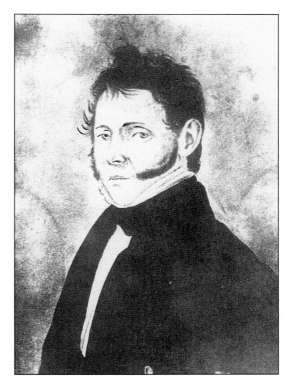

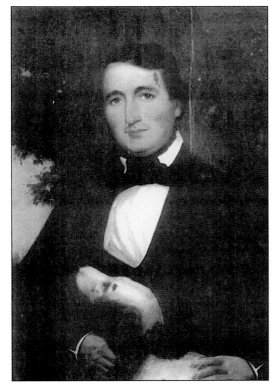

James Blair Gilmer, an early Bossier resident, was considered one of the wealthiest men in the entire state. He personally owned 13 plantations in Louisiana, Arkansas, Texas, and Cuba. His plantation house, The Orchard, was one of the most palatial homes in North Louisiana. James Blair Gilmer was embarking on a new business venture, a sugar plantation in Cuba, at the time of his death in 1856. He was 41 years old.

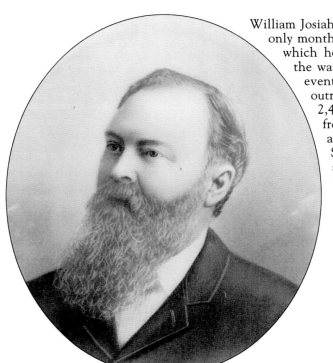

William Josiah Hughes came to Bossier Parish only months before the outbreak of war, in which he rose to Captaincy. Following the war he farmed, merchandised, and eventually owned, 3,520 acres of land outright and half interest in another 2,400 acres. In 1888, he moved from his home in Rocky Mount and founded the town of Hughes Spur. His funeral in 1921 was attended by fellow masons and numerous friends.

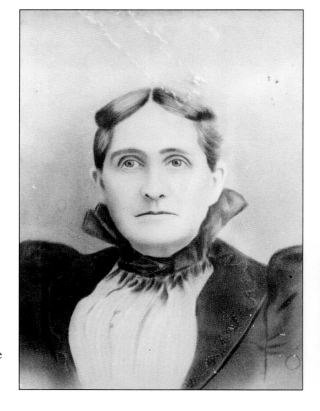

Mary Clark Hughes was the daughter of Daniel Clark and Malinda Martin Clark. She married W.J. Hughes on September 26, 1866. For years they lived in Rocky Mount where she became the mother of William C. (a state legislator), John F., James A. (a farmer), and Belle (attended school in Shreveport). She died two years after her husband, in 1923. Their first home still stands and is now a museum to early Bossier residents.

William Giroud Burt is one of only two Civil War colonels buried in Bossier Parish. He was born in Edgefield, South Carolina, February 11, 1843, and died at his plantation home, Utopia, August 29, 1890. At the age of 17 he entered the Confederate Army, and before he was 21 years of age he was promoted from that rank to colonel of the 22nd S.C. Infantry, for "distinguished valor and skill."

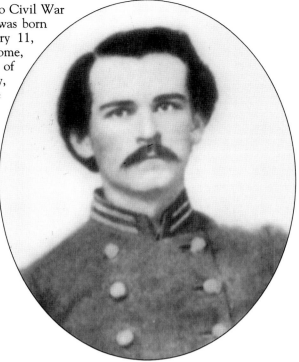

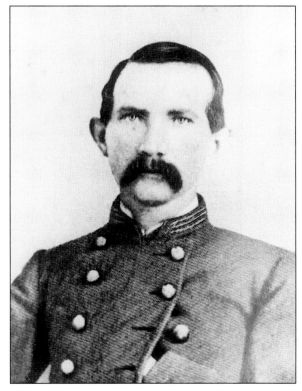

Richard Johnson Hancock was a Bossier resident who rose to Captaincy during the war between the States. While at war he met a young girl in Kentucky, with whom he fell in love. So, after the war, he returned there to settle. His descendants still raise race horses in Kentucky. He returned to Bossier in 1896 to properly mark his parents' grave sites. The Benton Chapter of the United Daughters of the Confederacy was also named after him.

Newsome Andrew and Elizabeth Rebecca Young Durden came to Bossier Parish in 1849, while on their way to the California Gold Rush. They liked the beauty of the area and stayed, eventually carving out a 2,000-acre plantation. Both are buried in unmarked graves in the Durden Cemetery, at their old home on Bodcau Bayou.

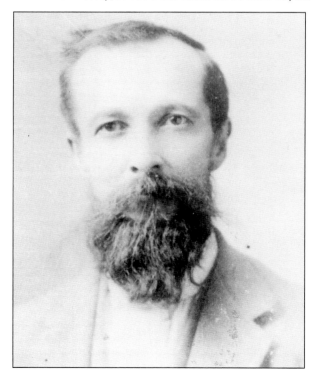

Hartwell Marion Matlock was born on November 18, 1842, in Marshall County, Alabama, the son of Charles and Margaret Elivira Holloway Matlock. This photograph was taken about 1870. Marion Matlock was said to be very fond of his beard and proud that it was never stained with tobacco juice. He died April 20, 1938, in Plain Dealing, Louisiana, and was buried in the Boggs Cemetery, near northern Bodcau Bayou.

Charlotte Dove O'Daniel was the wife of John Henry O'Daniel. They came to Bossier Parish in the 1830s and settled on the Manuel O'Garte Spanish land grant and ran the O'Daniel Ferry across Bodcau Bayou. Charlotte was born about 1815 in Mississippi and is thought to be half Cherokee Indian. After her husband's death, she moved to Arkansas, apparently to be near her native people.

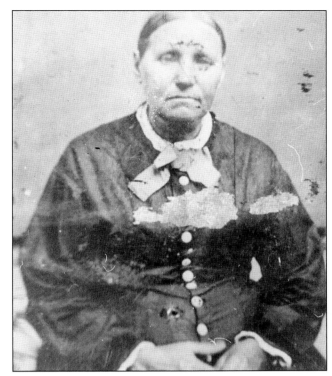

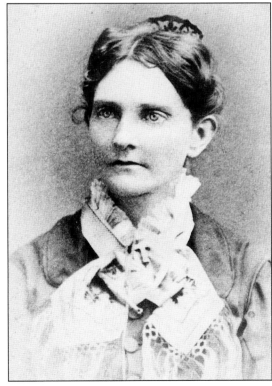

Jane "Jennie" Crawford Hancock was the daughter of Bellevue attorney Tom Crawford. In 1861, she presided over The Ladies' Military Aid Society of Bossier with Maggie Moore as secretary. Their executive committee was comprised of Mattie Maples, Mollie Jones, and Kate Hodges. They collected blankets, knitted socks, and gave concerts to raise funds for the Confederate cause. She married Thomas B. Hancock.

15

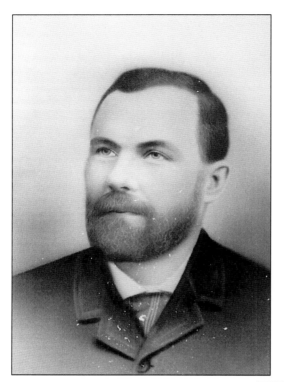

Thomas W.W. Stinson was the third generation Stinson to live in Bossier, but the first born here. His father, Robert, established the Rough and Ready Plantation that is still owned by the Stinson family. T.W.W. Stinson was primarily a farmer and rancher, but was also a founding member of the first public school in Benton in 1890 and served on the Levee Board in 1900.

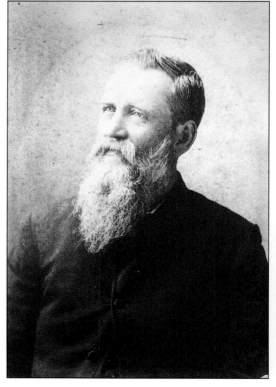

Robert Emmett Wyche had been a major in the Civil War. He was elected the first Democratic sheriff of Bossier following reconstruction, in 1878. During his tenure as sheriff he had to perform the second legal hanging in Bossier Parish. R.E. Wyche broke his left thigh and was transported by rail to Dr. Allen's Infirmary in Shreveport, where he died September 26, 1889.

John "Ford" Edwards defeated his wife's brother, R.E. Wyche Jr., to become sheriff of Bossier from 1904 to 1920. Ford Edward's mother died when he was an infant, and as his father was legally blind, he was raised by his grandparents. He was married to Hattie Wyche and they had three children. He died April 11, 1924, and is buried in the Fillmore Cemetery.

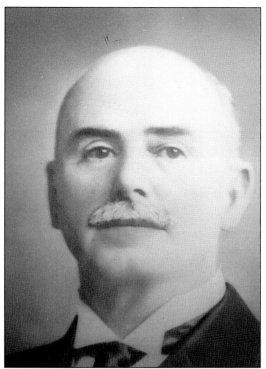

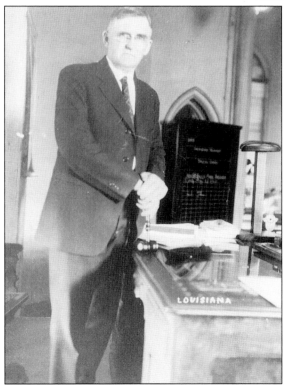

William Clark Hughes served for 26 years as a member of the Louisiana State House of Representatives and at one time was Speaker of the House. He was born in Bossier at Rocky Mount and died at his Kingston Plantation, August 20, 1930, while trying to extinguish a fire caused by lightning. When he went to douse the flames with water from a metal cistern, the charge electrocuted him.

17

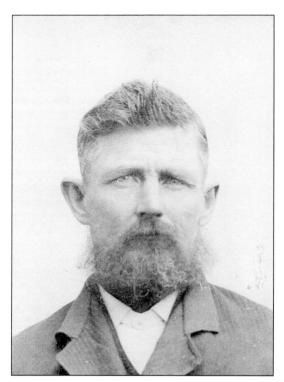

John J. Roberson was a resident of the Carterville community in northern Bossier Parish. Born August 19, 1852, he first married Frances E. Spurlin and after her death married Helen May. He served as postmaster of Carterville from 1895 until the office was closed in 1909. He died March 14, 1934, and is buried in the Salem Cemetery.

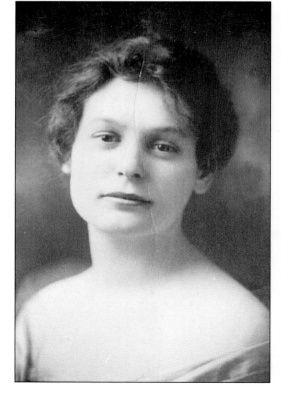

Mattie Elizabeth Durden, was born November 2, 1892, the daughter of early Bossier settlers Newsome and Elizabeth Durden. She spent her lifetime in the service of others as a nurse, including during battles of the World Wars. She died in 1970 and is buried in the Durden Cemetery on the old home place.

Elizabeth Vaughn Malone Andrews is the matriarch of many of the Malone, Hamiter, and Barnett families of Bossier. She and her first husband G.W. "Wash" Malone lived in Bienville Parish and had sons Iley Upton and Madison Gage Malone, where Wash Malone died. She then married J.W. Andrews of Bossier. They had daughters Marina Lavenia, who married R.E. Hamiter, Mary Caroline, who married Callaway Barnett, and Mattie, who died young.

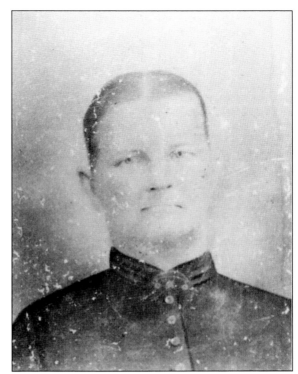

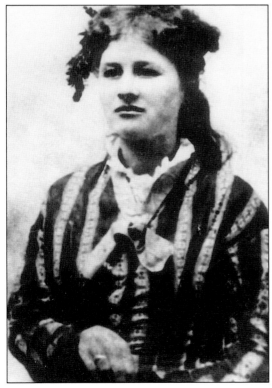

Willie Bennett Hudson lived in the Redland Community of northeastern Bossier Parish, Louisiana. She was the wife of Amos Hudson and the mother of Shelton (Buck), Ryden (Doc), Jim, Drew, John, Jeff, and Daniel Hudson. Many of their descendants still live and work in Bossier Parish.

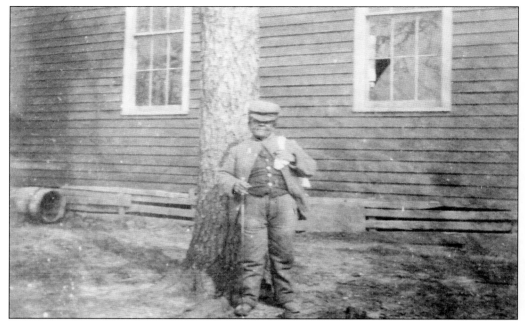

This picture is of Manry Carter. Slavery was a sometimes brutal system that had many opponents. But many of the released slaves chose to stay in the communities in which they lived. This is one of the only known photographs of an ex-slave from Bossier Parish. Mr. Carter was brought to Bossier by Captain William Josiah Hughes from South Carolina. He was just over 4 feet tall and lived near the village of Benton. He died in 1915.

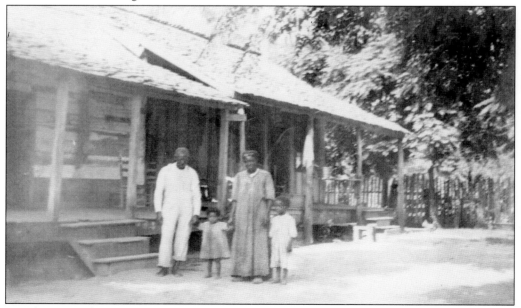

"Uncle Sam and Aunt Cassie with their adopted children." Bossier adoption records reveal that Sam and Cassandra Eley adopted a child named Lee on December 11, 1905. The child's mother was Eliza Porter, who was described as a "femme sole." Cassandra Eley is buried in the Bellevue Cemetery. Sam's last known residence was Texarkana.

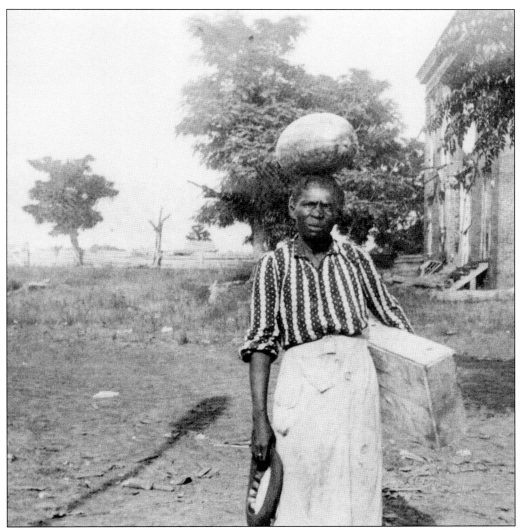

This unknown Bellevue native beautifully exudes her African heritage. Her hat is in her right hand, a fruit crate is in her left, and a watermelon is balanced on her head. This photograph came from the Abney Scanland collection in the Bossier Historical Center archives. Another photograph, not shown, was of her walking away from the camera, watermelon still balanced on her head. The building in the background is the Bellevue Courthouse shortly before it was torn down. The identity of this lady has always been a mystery, even to the Scanland family. It is only known that she lived somewhere near Bellevue, Louisiana, before 1910.

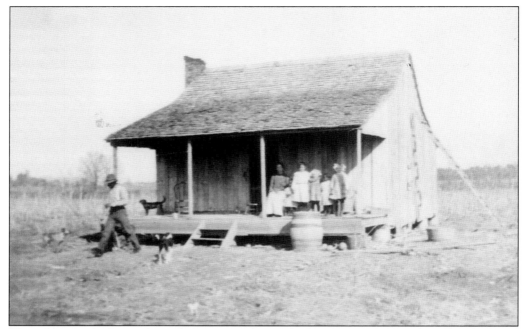

This photograph shows the rudimentary style in which many Bossier residents lived around the turn of the century. The family lived in the Benton community and have never been identified. This photograph was taken about 1910, by Mattie Scanland, youngest daughter of William H. Scanland.

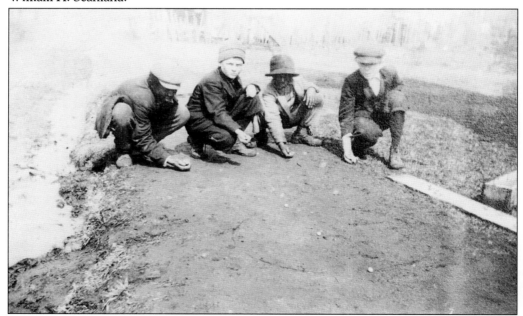

Two white boys and two black children play a game of marbles in Plain Dealing, Louisiana. One of the white boys is believed to be the brother of Beulah Allen Findley. This photograph was taken by Beulah's father, John H. Allen. His collection includes a great many photographs of people at leisure, but unfortunately few are identified.

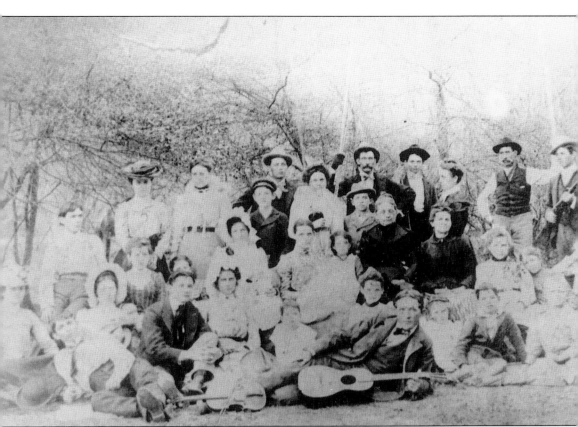

This 1902 photograph of a picnic at Greggs Landing near the town of Koran in South Bossier gives some idea of the entertainment of Bossier's early youth. The front row contains Adeliede Took, Clint McClanahan, Connie Connel, Harvey Stewart, Jessie Love, Owen Evans (boy), Billy Stewart (with guitar), Winnie Davis Love, Theo Evans, and Johny Gilmer. Seated are, center, Eva Connel, Bonnie Evans, Leona Sibley, Mrs. Eugene Sibley (with Marie), Albert Houston (boy), E. Aiken, John Love (boy), Mrs. Ida Evans with baby, Lille Evans, Susie Lee Evans, Mrs. Robertson, Mrs. John Love, Bessie Sibley, Mary Lee Love, and Linda Sibley. The back row contains Anna Yearwood, Nena Houston, Floyd Gilmer, John H. Sibley, Hiram Evans, Mrs. C.K. McClanahan, Eugene Sibley, and Herbert Evans.

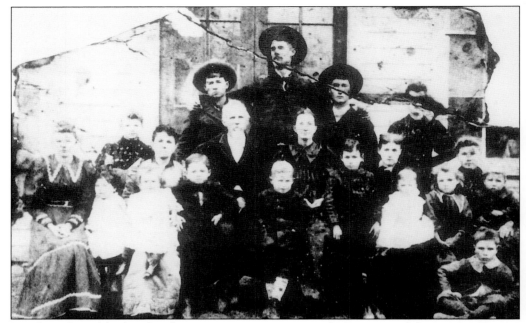

Family and neighborhood gatherings were quite commonplace in turn-of-the-century Bossier. It was one of the few forms of entertainment available to those with little means and no desire to travel long distances. This photograph was taken in front of the Tom Weeks place in the Redland community. The small boy in the middle is Daniel Whitaker Hudson, who was born in 1886. The man in the back center is Cebe Mays, a mechanic.

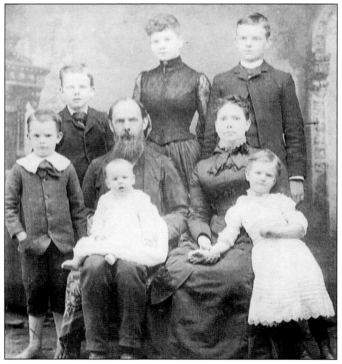

Pictured here are William Henry Scanland Sr., his wife Adelaide Amelia Abney Scanland, and their children. The children, oldest to youngest are John Milton Scanland, Kate Scanland, Abney Downs, William Jr., Mabel Abney, and the baby, Frank Worth Scanland. This portrait was taken in the summer of 1889, in Bellevue, Louisiana. John Milton would become a doctor, Abney would remain in the family publishing business, and Frank would be a highly decorated naval officer. The ladies in the family were equally known for their abilities.

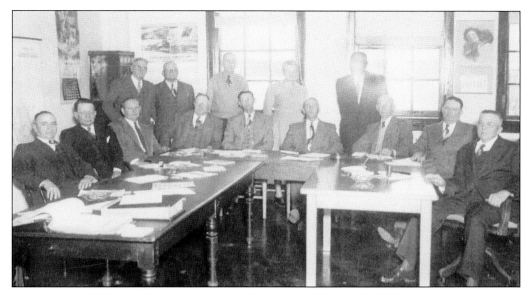

This is the 1938 Bossier Parish Police Jury. Pictured from left to right are, (front row seated) J.W. Anderson, J.J. Waggonneer, N.N. New; and absent was H.H. McHaffey; (seated) A.C. Smith, Agriculture Agent; W.B. Wilbourn; T.R. Miller; E.D. Barnett; and A.L. (Tony) Bundy; (standing) D.E. Burchett, parish engineer; E.W. Rice; F.W. Witherspoon; unknown; N.W. Claxton; and W.W. Carter Sr. (seated at the ends) V.V. Whittington, Parish Treasurer and J.H. Mercer. Their budget was $115,800.

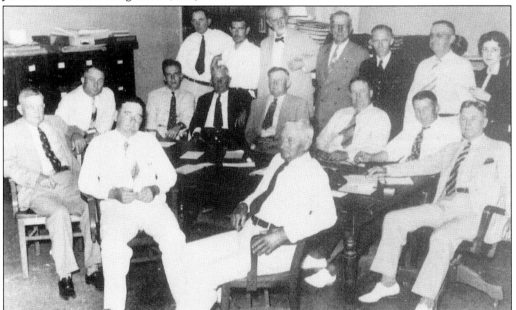

This photograph is of the 1952 Bossier Parish Police Jury. Seated are R.L. Bumgardner, A.S. Burt, B.F. Bounds, U.R. Mayer, C.C. Young, W.A. Clark, R.B. Kilgore E.D. Barnett, and W.A. Gandy. Standing are Mr. J.H. Mercer, M.R. Bolinger, D.E. Burchett, Mrs. Ida Calhoun, and Mr. V.V. Whittington. That year they raised the pay of their Justices of the Peace and Constables, from $5 to $10 per month. The operating budget was $364,960.

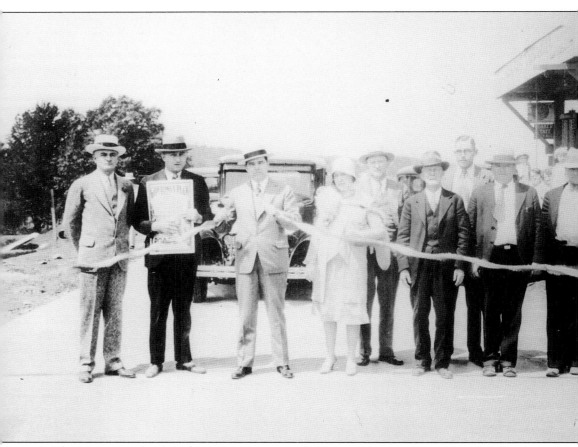

The Dixie Overland Highway was begun in 1918 as a private venture, with headquarters in Georgia. During the 1920s and '30s it was taken over by Huey P. Long as part of his massive road-building projects. The following people were present at this dedication of Dixie Overland Highway (now Highway 80) in 1930: (left to right) Robert Brothers, considered by many to be Huey Long's "right hand man"; Volney Voss Whittington, state representative from Bossier Parish 1928–1932; Governor Huey P. Long; Mrs. H.P. Long (wearing the fox stole); J.R. Wendt, state maintenance engineer, formerly Bossier Parish engineer; J.G. McDade, president of Bossier Parish Police Jury; and V.R. Rucher. The last two men have never been truly identified, but they are believed to be D.A. Horton Sr. and his brother. They owned the store in the background.

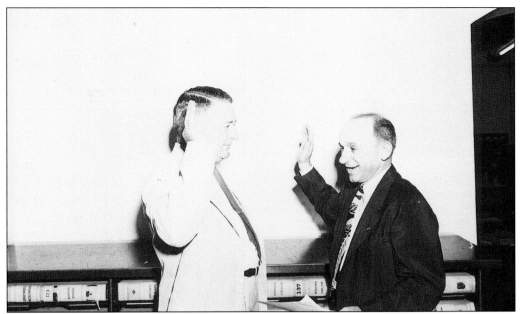

Pictured here is Sheriff W.E. Waggonneer being sworn in by the Clerk of Court A.J. Broussard in 1948. W.E. Waggonneer would remain sheriff for 28 years until his sudden death in 1976. Under his leadership the sheriff's department would grow tremendously and begin using modern methods of crime-solving and detective work. All told, W.E. Waggonneer remained in the sheriff's department for 45 years as deputy and then sheriff.

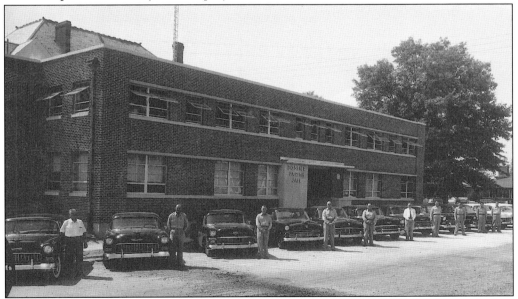

This photograph taken in August of 1956 shows the Bossier Parish deputies lined up with their patrol cars in front of the new Bossier Parish Jail. Positively identified are: 1) Ray Wilson, 4) Ralph Deville, and 6) J.W. Hollis. Others known to be in the department that year were Reese Hardcastle, Frank Goodman, Carleton Foster, Bubba Green, Vol Dooley, and Tommy Beasly. These Fords had been recently purchased by the sheriff's department.

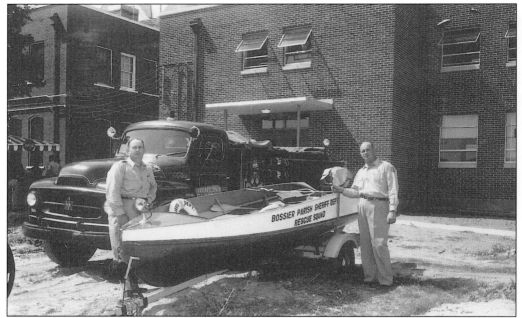

Shown here are Bossier Parish deputies Reese Hardcastle and Ralph Deville with the Benton Fire Department truck and the sheriff department's rescue boat. This photograph was taken August 6, 1956, during the ceremony to dedicate the newly finished jail behind them. The jail still stands although it is now the School Board Annex II.

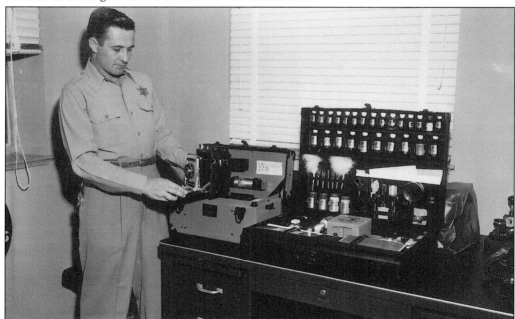

Bossier Parish Deputy Vol Dooley Jr. is pictured here with new photographic and fingerprint equipment. Mr. Dooley had trained with the Louisiana State Police and came to work for the department the year before to set up the fingerprint bureau. He would later be sheriff from 1976 to 1988. Mr. Dooley is now in charge of security at the Port of Shreveport/Bossier.

Neill A. Yarborough Sr. was killed in the line of duty on February 25, 1925, helping Bossier and Caddo law officers apprehend a fugitive. The suspect fired at Neill from point blank range. Joe "Son" Airey was captured and lynched for his role in the killing. It took his son, Neill Yarborough Jr., 72 years to get his father's death recognized properly.

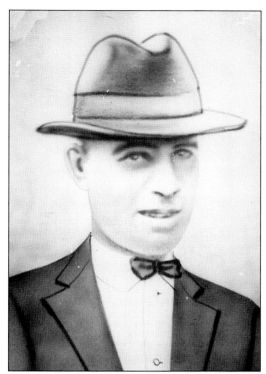

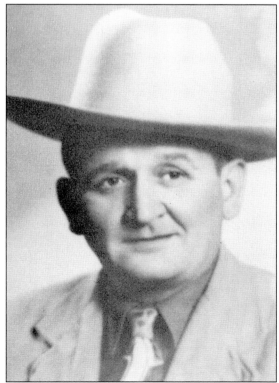

Maurice Miller was killed in the line of duty, on February 28, 1954, as he was serving a warrant on Mark West. West himself was killed in a hail of bullets and the house caught fire and burned. Maurice Miller was survived by his wife Jane Miller, a son, John S., a daughter, Miss Bennie Miller, and his mother, Mrs. Ethel Miller.

Richey's Bait Stand, near Haughton, was the location of a grisly execution-style murder that would effect the nation. Floyd "Chigger" Cumbey would later testify that "Cadillac" Jack Favor was the triggerman. The resulting trial, conviction, retrial, and acquittal of Cadillac Jack would become the basis for a made-for-television movie. "Chigger" would continue to testify that Jack Favor did the murders and Jack would protest his innocence.

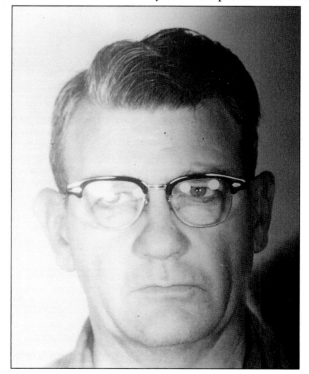

"Cadillac" Jack Favor was tried in 1967 for the murders of bait stand operators Mr. and Mrs. Richey. He was found guilty and sentenced to life in prison. Seven years later he would win a retrial claiming collusion among law officers. The second trial acquitted him. "Cadillac" Jack Favor was none other than the former World Champion steer wrestler from Tulsa, Oklahoma.

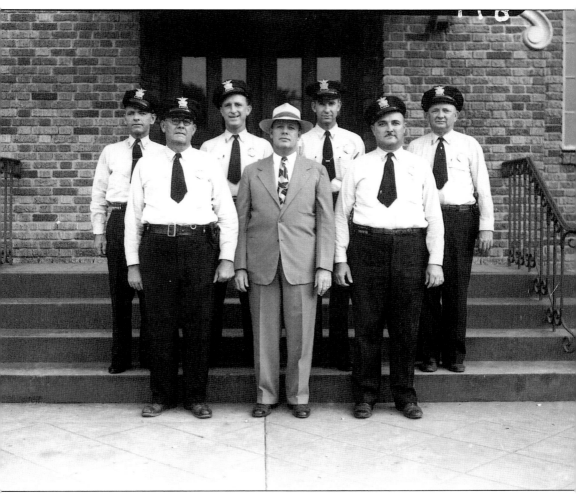

This 1945 photograph shows the Bossier City Police Department and was taken in front of the old city hall on Barksdale Boulevard. From left to right are (front row) Art Mangham, Ray Festervan, and John W. Wilkins; (back row) Jimmy Walker, J.Q. Lincecum, Kenneth Harold Moore, and J.D. Thibodeaux. Not only did the Bossier City Police Department have to handle the usual incidents that occurred in every other small town of that time, it also had to deal with the tough job of policing an area known as the Bossier Strip. The Bossier Strip was a collection of honky-tonks, bars, clubs, cafes, and supper clubs that catered to a massive number of tourists that came for beer, gambling, strip shows, and illegal sex.

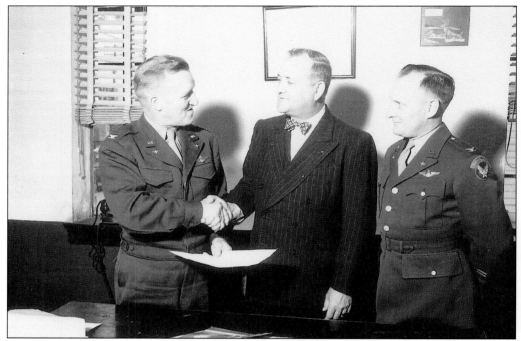

Bossier City Mayor Hop Fuller meets with two Barksdale Air Force Base officers in 1945. Bossier City has managed to maintain a good relationship with Barksdale, despite clashes between drunken airmen and city officers. Only four years earlier, that relationship had been tested to the core, when Private James E. Fahrnkopf was killed by a city officer.

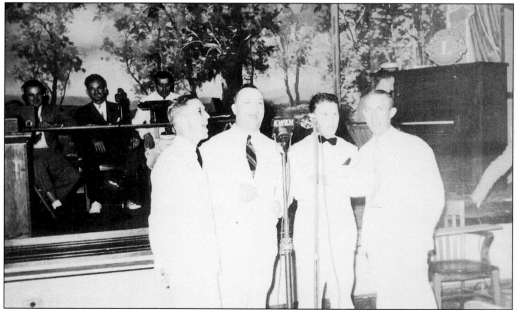

These four Bossier City Lions Club members competed for various awards given by the KWKH radio station. They are from left to right, Paul Dyson, Hop Fuller, Ira Harbuck, and Jack Dyer. In many ways, the early Lions Club promoted business and social changes in Bossier City.

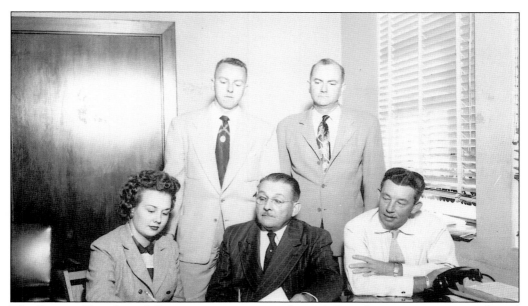

The Bossier Chamber of Commerce was organized in 1947 to foster economic growth and promote sound business practices. Its first president was V.V. Whittington, bank president, followed in presidency by Arthur Ray Teague, realtor, D.L. Patrick, lumberman, and James. L. Larkin, builder. This 1951 photograph shows James Ashley Sibley (seated), hardware merchant in Bossier and Shreveport. Harry Coffey stands at the back right.

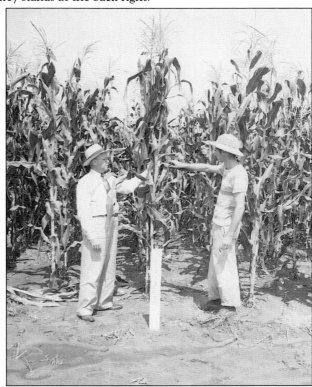

The Red River Valley Experiment Station was created in 1945 to help develop expertise in growing in Bossier Parish's lowland areas. A similar one in Homer developed techniques for hilly lands. This experimental corn crop in 1950 was demonstrating "hogging off corn." J.Y. Oakes was the superintendent of the station.

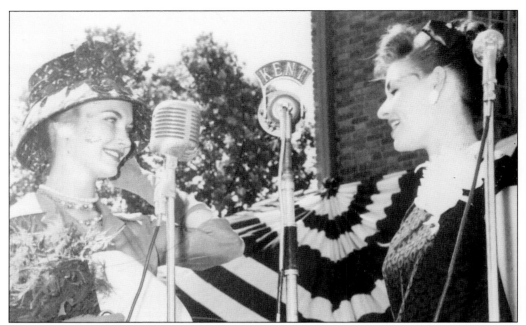

On the left is Ms. Eurline Howell, Miss Louisiana and Miss USA 1958, and on the right is Ms. Anita Thomasson. Eurline was described as "a Grace Kelly type, 5 ft. 6 in. tall, 119 lbs, with the near-perfect measurements of 36-23-35." She had a dazzling smile, blue eyes and long, honey-blonde hair. She spoke with a soft Dixie drawl and was a true Southern Lady. One official wrote "You will fall in love with her as soon as you see her."

Margaret Ann Horton, 1951 graduate of Bossier schools, became Miss Bossier City of 1952. She is the daughter of Mr. and Mrs. Cecil Horton of Bossier City. She won a free trip to Cuba, which she took with her mother. She attended Northwest College in Natchitoches and soon married John McCowen Jr., of Minden, Louisiana.

Two

HOMES AND FARMS

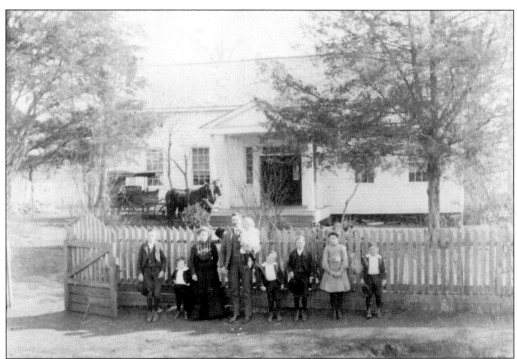

The D.A. Horton family of Fillmore are shown in front of their house, just after the turn of the century. It was located on what is now the southeast corner of La 157 and US 80. Their house is actually the old Connell Inn. The Connell Inn was built by and named for Thomas Dixon Connell about 1848 and for years served the community providing rooms to weary travelers. At that time the area was called Connell's Cross Road. In 1852, the crossroads and the post office were renamed Fillmore, after the 13th President of the United States. The house eventually crumbled into such a dilapidated condition that it was destroyed.

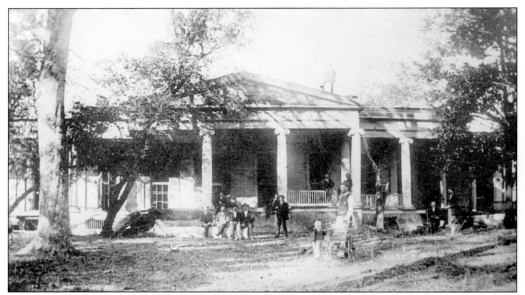

Pictured is the Orchard Plantation, of James Blair Gilmer, as it looked during its heyday. The house was 160 feet across. The interior contained two drawing rooms, each 30 feet square, connected by folding doors so that they could be converted into a grand ballroom. The grounds were beautifully landscaped and decorated with ornamental shrubbery. The furnishings were from France and England and brought via New Orleans by steamboat.

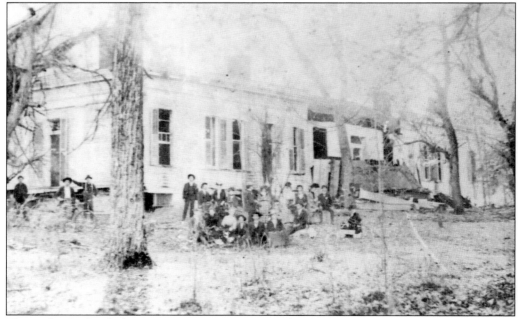

This is the Orchard Plantation, some 50 years after the death of its owner. Gilmer descendants are seated around. Part of the reason for its destruction was that the roof was sheathed entirely in copper and the doorknobs were of silver. The house has been ransacked by "collectors." At the last count, three of the doorknobs still existed. The house was located 4 miles south of Plain Dealing at the intersection of the Collinsburgh and Rocky Mount Roads.

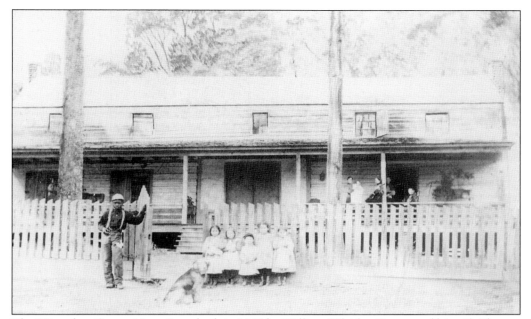

The "Grandma Cavett Home" was built in 1848 by William Whitley Cavett and his wife Eleanor Elizabeth Kennard Cavett. On the porch are Lydia Cavett Cummings holding baby Mattie Cavett. Seated on the banister with the guitar is Mattie Camilla Rozina Haden Thompson. Seated is Jimmy Conway Thompson Cavett. By the gate left to right are, "Sambo," Hal (the dog!), Willie Eleanor Cavett, Mary Cummings, James Richard Cavett II, Hazel Cummings, and Rozina Conway Cavett.

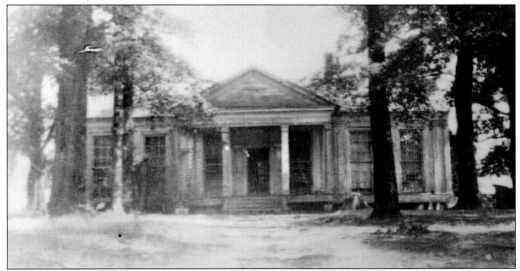

This photograph is of the home of Dr. James M. Milling. An interesting story is given about Dr. Milling. A mule was stolen from his lot in Bellevue in 1870. Dr. Milling and Mr. H.M. Underwood pursued the thieves 250 miles, capturing them at Vidalia, on the Mississippi River. They returned the thieves to Bossier Parish, where they confessed and were sentenced to jail. Milling and Underwood were praised for not carrying out the usual horse-stealing sentence—hanging.

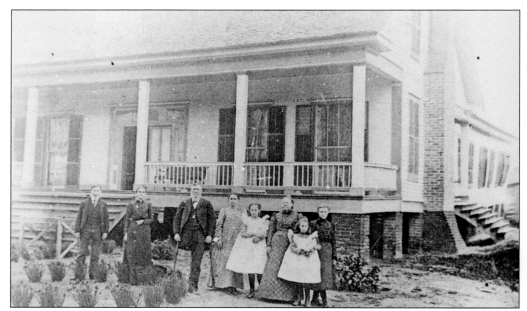

Dr. Paul Lawrence is shown standing with his family in front of his south Haughton home. From left to right are T. Humphrey Lawrence, Mary Lawrence (sister to Paul), Dr. Paul Lawrence, Eva Lawrence, Myrtis Lawrence, Mary Haughton Lawrence (wife of Paul), Sudye Lawrence (youngest of nine children), and Lucille Lawrence.

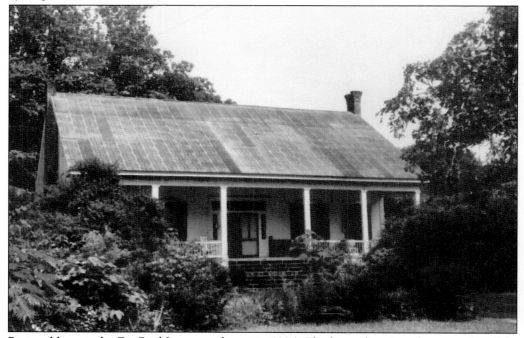

Pictured here is the Dr. Paul Lawrence home in 1995. The house has since been purchased by Howard Taft Prince III and meticulously restored. The upstairs attic has now been converted to bedrooms. The original house on this location burned in September 1883, and this house was built in the summer of 1884.

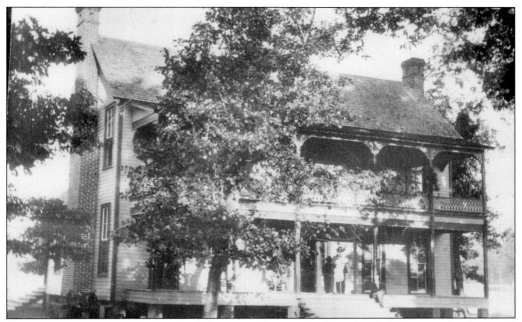

Photographed here is the Scanland home in Benton, built *c.* 1893. The paint buckets and various tools still sit under the porch, and the picket fence has not yet been built. William Scanland stands on the front porch holding the last of his children, Mattie Belle, who was born July 4, 1894. An older son sits on the front steps. At the time this photograph was taken, the Scanland home faced Benton Road. It has been heavily remodeled and now faces Lee Street.

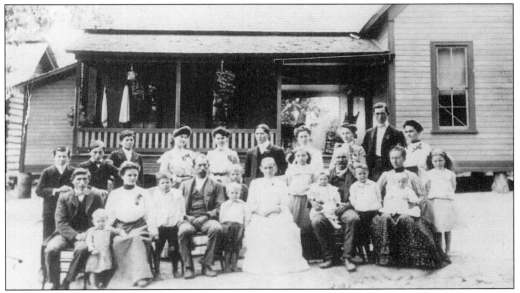

This is a 1903 picture of the McKinney home. At the front from left to right are: Nolan, his son Lotcheil, wife Ella, unknown, J.J. McKinney, Caleb, Martin, J.J.'s wife Ann, Anna Belle, Charlie Demoss holding Dolly Demoss, his son Hershel, Pearlie Demoss holding Buck, and then Addie Demoss. In the back are Tommy and Clarence McKinney, Archie Clark, Katie McKinney, Lena or Lillie Clark, Isaac, Ethel, Clara McKinney, and Clara Davis.

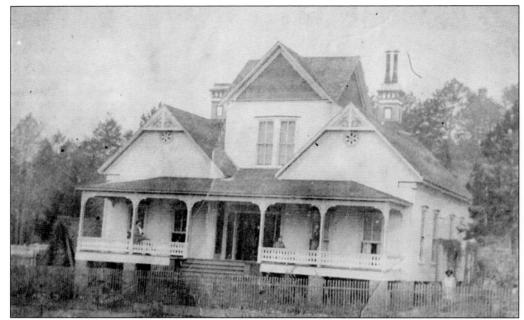

The Hughes Spur home of W.J. and Mary Clark Hughes was built *c.* 1888, when W.J. moved his family from Rocky Mount to the newly laid railroad tracks running north-south through Bossier Parish. He created the town of Hughes Spur and commenced business as a timber-cutter. This home burned about 1916, and the town he created has slowly dwindled.

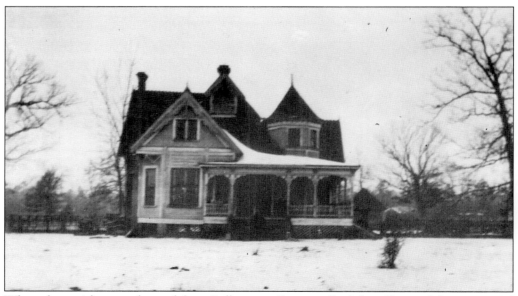

When the parish seat relocated from Bellevue to Benton all of the officers of the court, and indeed many of the citizens of Bellevue, also moved to Benton. This Wyche home was built in Benton about that time. It stood northwest of the courthouse, behind Ford Stinson's law office. Its Victorian design and gingerbread detailing were beautiful.

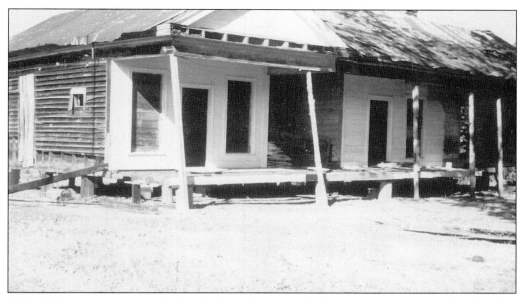

This 1967 partial picture of the Hughes House in Rocky Mount was taken shortly after remodeling began to make it into a museum for Bossier History. From this home, on November 26, 1860, Bossier voted to secede from the Union and proclaimed itself the Free State of Bossier, weeks before Louisiana seceded and months before Louisiana joined the Confederacy.

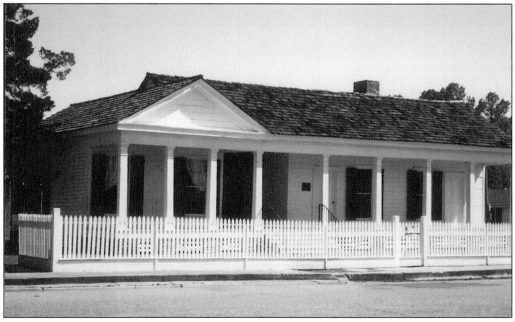

The Hughes House was moved to the old Benton courthouse square in 1995. The house has been refurbished, and efforts are now under way to collect furniture and rededicate the museum of Bossier Parish antebellum history. Throughout its history, the Hughes house has served as an office, home, school, and museum. It is one of only a few antebellum homes left in Bossier Parish.

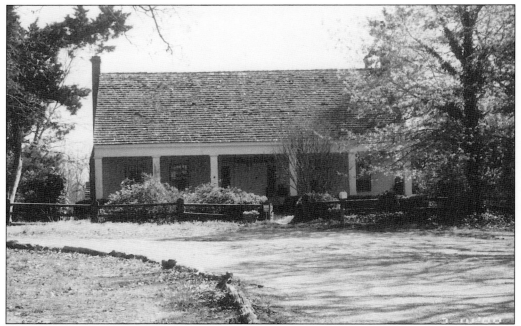

The Arnold Tidwell House, also known as The Homeplace, is another of the three antebellum homes in Bossier. The home sits on the Linton Road south of Benton. Originally a dogtrot log home, it was covered with clapboard siding and the dogtrot enclosed in the 1850s. The massive logs used to build the home are still visible upstairs.

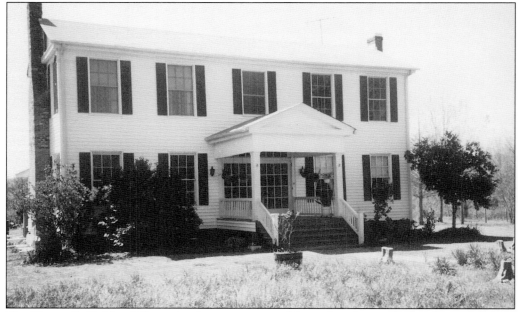

The Skannal's Oakland Plantation home was one of the earliest homes built in Bossier Parish. The rear part of the home was built in 1838, but had to be disassembled in the 1960s. The front part was built in the 1840s and is still standing. Its owners are currently restoring the house for the second time.

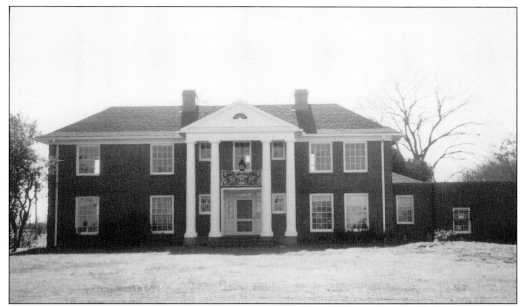

The Walker Home was built south of Bossier City in the 1940s by John Walker Sr. It has now been purchased by the City of Bossier, and plans for it include a community center and art decorations. It is being restored by the City.

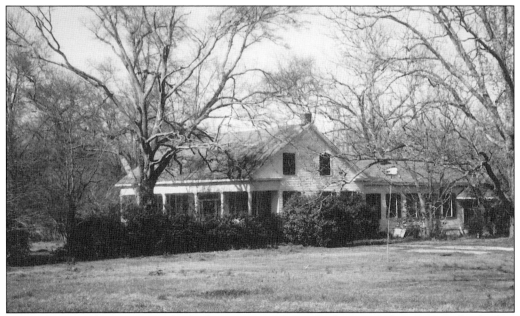

The Ashpoint Plantation was built about 1880 and was the home of Elam S. Dortch, the last known living Bossier Parish Civil War Veteran, when he died in 1943. During his lifetime he moved the house twice, because of its original site next to the river. The last time it was totally disassembled and moved to its current location south of Taylortown.

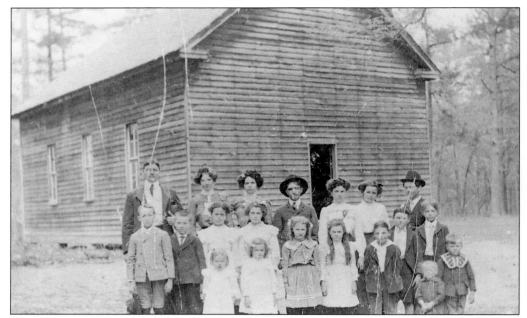

This 1902 photograph of Brushy School shows the crudeness of Bossier's early education system. Levy Winham was the teacher. Known to be in the picture are Gussie, Homer, and Mattie Gardner. It was Mattie's first year at school. The school was closed by January of 1905, when the children were bused to Plain Dealing.

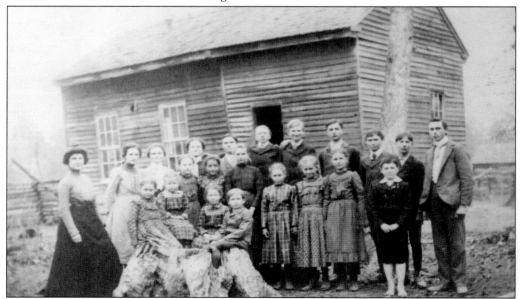

Pictured here is Ivan School in 1900. Annie Oliver Hughes is the teacher. The bottom row contains: Vey Rabb Spruill*, Linda Bundy Jagers*, Lenora Bundy Jordan*, Margaret McCall Kirklin, Maggie Rabb Pearce, John McCall*, ? Burks, Berttie Burks, Edna Rabb, Hattie McCall Bass, and John Morrison. At top, left to right are: Grey McCall Grant, Robert Morrison, Lettie Gladney Hosier, Sam Morrison, Robert Whittington, Sam McCall, Julian Whittington, Cy Morrison, Alaric Whittington, and Ivan Whittington. (*Seated on stump.)

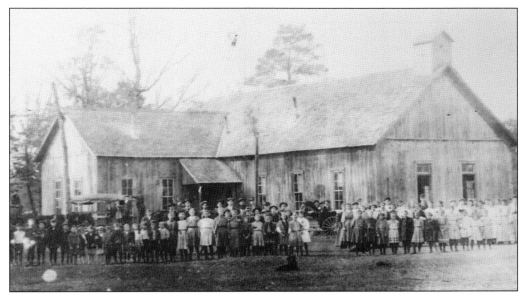

This is the 1908 Alden Bridge school. With about two hundred workmen employed at Alden Bridge sawmill, the area boasted quite a large school for its time. Built about 1888, Alden Bridge would become large enough to justify a post office in 1890 with the first postmaster being John Picket. The town would remain a thriving community until December 31, 1942.

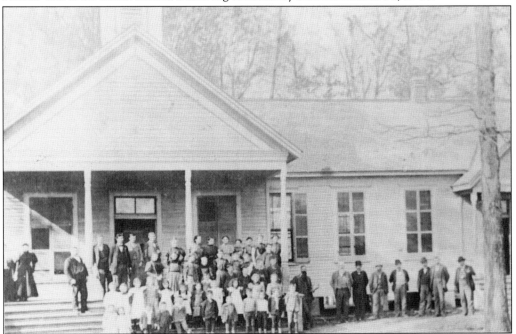

The above image is of the 1898 Pioneer School. The men in the picture are Haywood H. Montgomery, John G. Allen, Thomas H. Carter (Baptist minister), Leon T. Sanders Sr., Sam H. Cochran, William H. Demoss, W. Benton Boggs, and Joseph E. Adger. One pupil, Pat Tugwell, rose to become Louisiana state treasurer. Together with his brother Lloyd they attended Pioneer when their father was railway depot agent for Plain Dealing.

The Elm Grove School was built in the summer of 1921, so that the Atkins and Taylortown Schools could be consolidated. Mr. Van Os was the architect and M.H. Cleveland the contractor. At that time the school encompassed all grades. Later it would become Redmond Spikes and then Elm Grove Middle School.

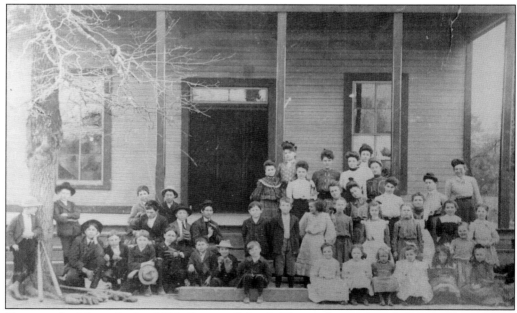

Photographed here is the 1912 Benton School. The students, from left to right are (first row) unknown, Gordon Eggleston, Sidney Adger, Ernest Belcher Jr., and Murhpy Baysinger; (second row) Ruth Eggleston, ? Bailey, Elizabeth Wyche, unknown, Margery Jones, Haywood Montgomery, Bobby Montgomery, and Lena Mae Montgomery; (third row) Beulah Taylor, Mary Louise Wallace, Howell Cade, Willis Wyche, Martha Henderson, Sally Spataro, Neil Baysinger, Theo Burt, and Miss Etah Colvin, teacher; (fourth row) Jennie Zeigler, ? Baysinger, Margorie Hosier, Gordon Eggleston, unknown, and ? Baysinger; (fifth row) Dick Coker, Curtis Youngblood, Sandy Spataro, Robert L. Wyche, ? Baysinger, and Ford E. Stinson.

The school building for the 1917-1918 school year at Koran was a source of pride for the two teachers, Miss Helen Roach and Martelie Lee. They wrote that this was their "first year in the new improved two-room building." Many Bossier schools would remain small, primitive affairs until the 1920s when large brick buildings were built.

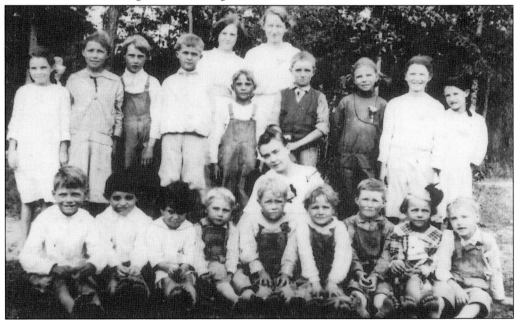

This is Adner School in the 1915-1916 school year. The children are from left to right (first row) Elmer Treadway, Shrell Busby, unknown, Fred Busby, Frank and Leo Stafflebach (twins), Bynum E. Murphy, Velma Treadway, and Quinton Busby; (back row) unknown, Bertha Mae Treadway, Clifton Busby, George Stephens, Jewel Busby, Marlin Busby, Murtie Rounsavall, Brytha O. Murphy, Louise Treadway, Velnia A. Murphy, and Freda Stafflebach. Elmer and Velma Treadway were twin brother and sister.

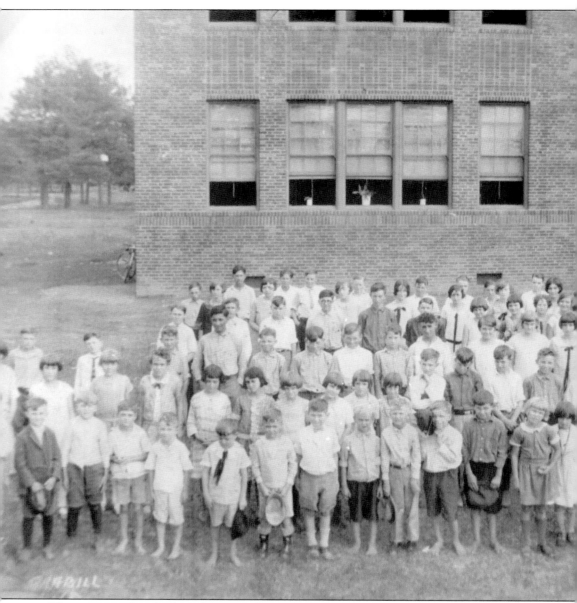

The entire student body is shown in this pair of 1925-1926 Benton School photographs. The building that the children are standing in front of was built between 1922 and 1924. The student body moved in January 1924. It cost $75,000 and was designed by Mr. Edward F. Neild and built by McMichael Construction.

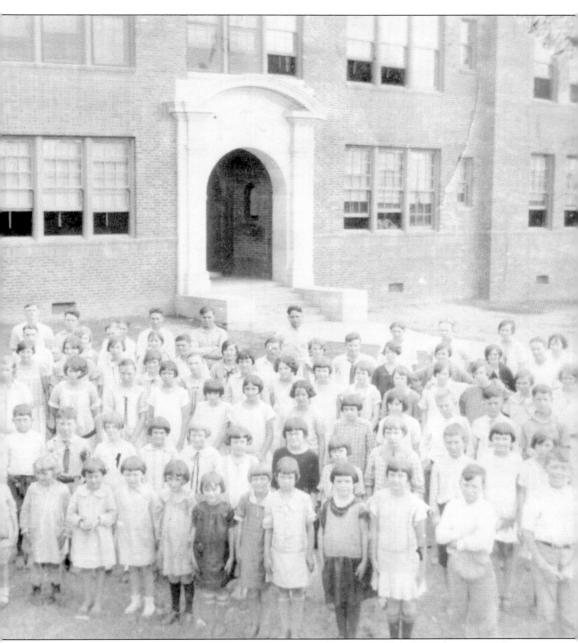

There were 140 students in the year of 1924. Agriculture was added to the curriculum, and there were four trucks (buses) transferring students. By 1927 there were ten teachers and an enrollment of 183 children. Five trucks were used to transport 107 children. Attendance was 95 percent.

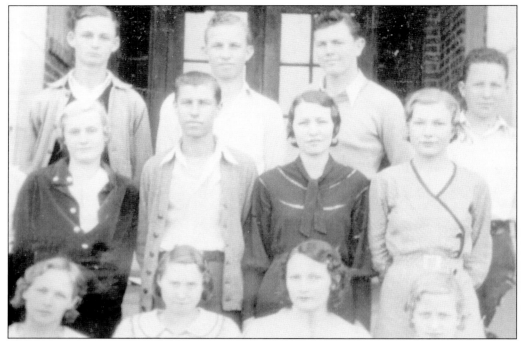

This is the 1933 Benton Graduating class. Members from left to right are (bottom row) Marjorie Jones, unknown, and Bobby Montgomery; (middle row) Harry Johnson (14 years old, also valedictorian), Kate Stafford Johnson, unknown, unknown, and Gennie ? Taylor; (top row) unknown, unknown, Sydney Adger, and James Brice.

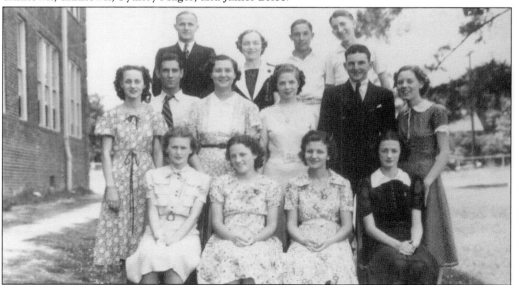

Pictured here is the 1938 Benton Graduating class. Members are from left to right (bottom row) Kathleen Scarborough, Cybil Ethridge, Majorie Lott, and Martha Ree Jones; (middle row) Eugenia Wyche (twin of Emmett), C.C. Parker, Ann Whittington, Juanita Keith, Hartwell Allison Jr., and Eunice Jones; (top row) Emmett Wyche, Virginia Neeson, David Grisham (died in World War II), and Robert Wallace.

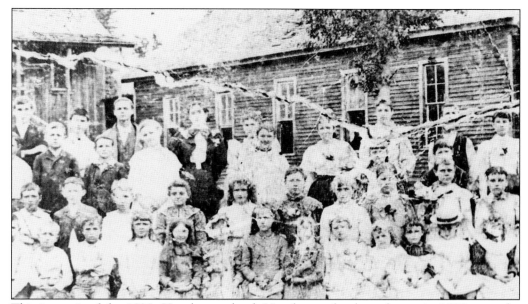

This image is of the 1890s Haughton school. Haughton school was begun in 1886, over the store of G.W. Smith on the north side of the tracks. In 1887 it was moved to "just back of the G.E. Carson residence." The elementary school is held in the building on the left and high school in the building on the right. Persons known to be in the picture are Clifford Connell, Eula Connell, Lucille Edwards, Mamie Edwards, and Kate Odom. This original photograph is the oldest picture of a school in Bossier Parish.

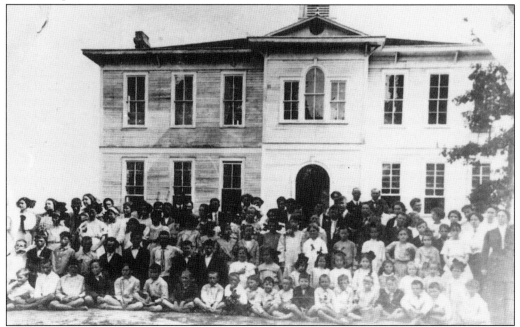

By 1906, Haughton school had moved to its present location, and a newer wooden building was built. It still encompassed all grades. The entire student body came out for this picture. This wooden building stood until 1927 when the newer brick building was built.

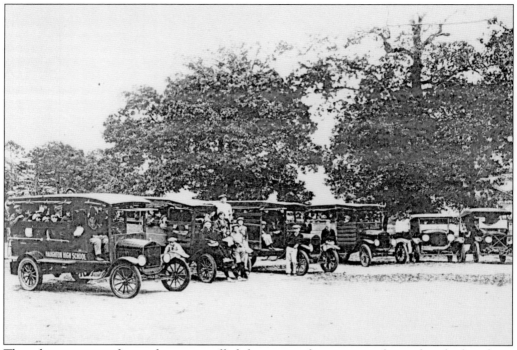

These buses, or transfers as they were called then, carried approximately two hundred students to and from Haughton school. The transfer with the boy leaning against the fender is driven by D.A. Horton Jr. of Fillmore, Louisiana.

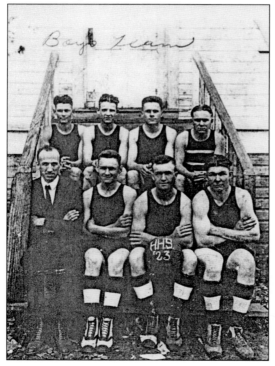

This 1923 Haughton basketball team played outside on a dirt court, yet they managed many wins against other Bossier schools. Known to be in the photo are Belton Madden, Lee Lawrence, Harry Leach, Jacob Murff, Chandler Gillette, and an Allen boy, whose name is not remembered. This photograph is owned by D.A. Horton Jr., of Fillmore.

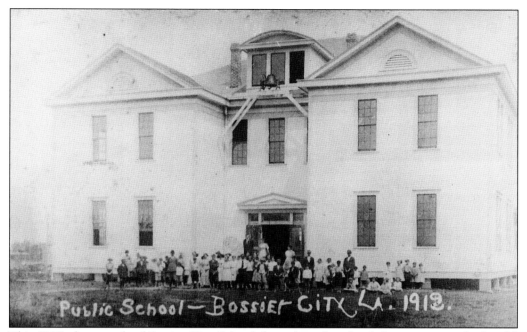

This 1912 photograph of Bossier City School shows how far schools have come in the last 87 years. Bossier City was still just another small town in Bossier Parish, in fact Plain Dealing was the largest town in the parish about this time. This school was located just back and to the right of the present Bossier City Elementary School.

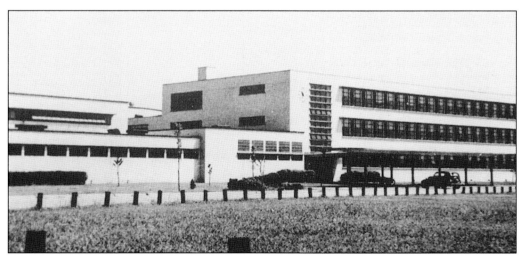

The brick Bossier High School was finished and occupied in 1940. The architect was Samuel G. Weiner of Peyton and Bosworth. That year there were 889 students in elementary grades using 25 teachers and 473 students in high school using 17 teachers. The football team and band would be a tremendous source of pride for the school.

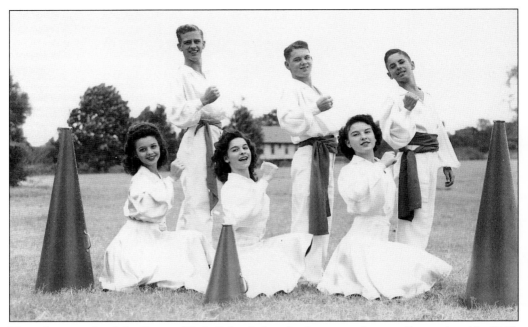

This photograph of the Bossier High School cheerleaders was taken on September 13, 1945, by Jack Barham for the *Shreveport Journal* newspaper. The girls are, left to right, June Waites, Jo Ann Hough, and Cleta Gage. The boys are, left to right, Clifton Watkins, Charles Bookter, and T.O. Spataro.

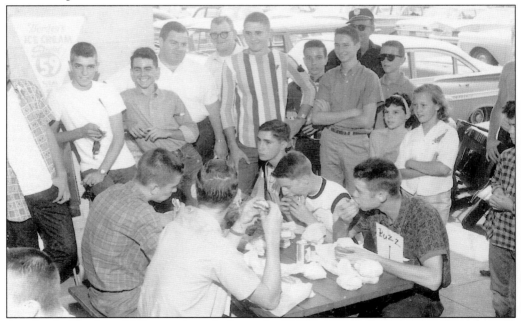

As school officials and fellow students look on, the 1963 Bossier High school band boys happily fill themselves in a hamburger-eating contest during May. These and other money-raising efforts helped the band attend the June 1963 Lions International Parade in Miami, Florida. Gaylon Daigle stands in the crowd watching.

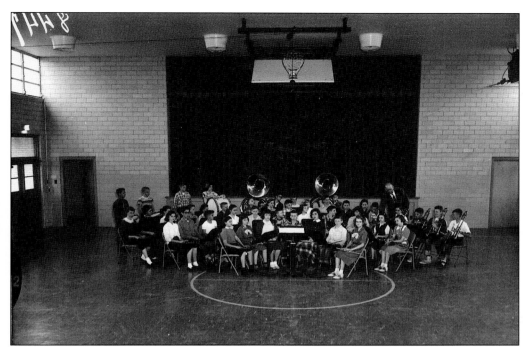

This 1956 photograph is of the R.V. Kerr Elementary School Band. The R.V. Kerr School was officially opened during the 1955-1956 school year. The school was named after Robert Vance "Bob" Kerr, who was Bossier Parish School Board superintendent from 1921 until after 1953.

This photograph of the Waller Elementary basketball team was taken by Jack Barham for the *Shreveport Journal*, on March 1, 1956. The teacher is known to be Miss Quincy Linceceum, who later married a Coach Robb from Ruston.

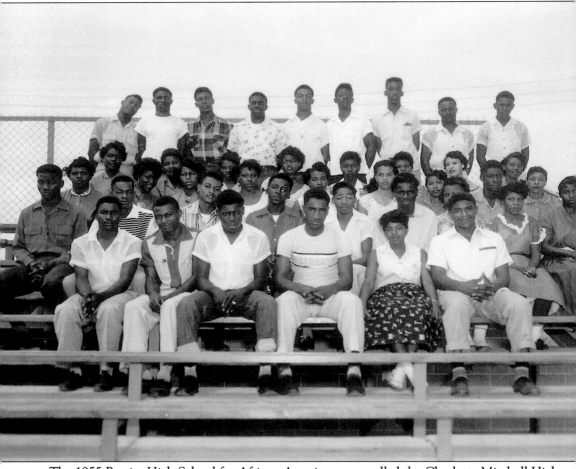

The 1955 Bossier High School for African Americans was called the Charlotte Mitchell High School. The 1955 graduates included Ada Mae Adams, Curtis Bates Jr., Audrey V. Bell, Walter C. Beatty, Earl Brown Jr., Cora B. Burks, Richard Connon, Melvin Carter, Sallie Mae Cook, Bessie Mae Cooper, Neitha A. Daniels, Edward L. Davis, Lizzie M. Galloway, Lillie M. Gardner, Rogers Green, John Harvey, Henry Hawkins, Leamon Hicks Jr., Mattie Pearl Hicks, Rosie Lee Hollingsworth, L.D. Horton, Lula Mae Johnson, Elvin Johnson, Hines, Maxine Hodge, Deloris M. Crayton Jones, Ola V. Lee, Willie T. Lee, Maurice Mayweather, Charles McGee, Charlie Lee Nelson, Clifford Newkman, Marvis People, Ella V. Reed, Mary J. Reed, Charlie Sanders, Lucy Jane Shaw, Joe R. Sloan, Emmitt Stills, Gloria Strange, Charlene E. Taylor, Ehelda E. Walker, Arthur L. Washington, Evelyn M. Williams, Eliza M. Williams, Mary Elizabeth Willis, Bertha Woodson, Kenneth Wayne Woodson, and Gertrude Young.

Three

CHURCHES AND BUILDINGS

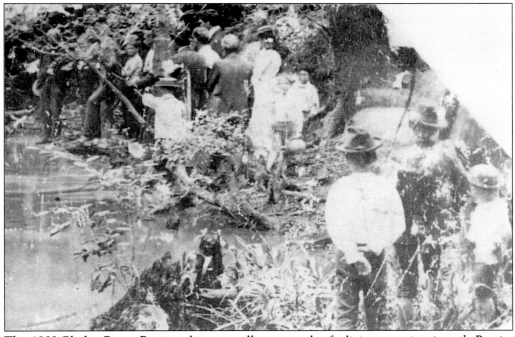

This 1903 Clarkes Bayou Baptismal is an excellent example of religious practices in early Bossier Parish with small churches for small congregations throughout the parish. There were very few large churches at this time. It also shows the faith of someone's conviction in being baptized, despite the hazards of what lived under the water. W.T. Strain was pastor of this southern Bossier Parish church at the time of this baptism. Modern indoor baptisms ensure that very few parishioners remember when they were performed in outdoor creeks and ponds.

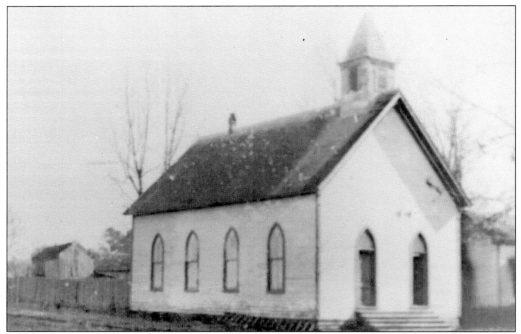

The First Presbyterian Church of Plain Dealing was organized on July 26, 1899. In August 1899, a meeting was held for the purpose of collecting funds and planning the construction of a house of worship. The first church building was finished in the latter part of 1900, and on January 1,1901, the bell rang for its first church service. The building at Plain Dealing burned on September 3, 1970.

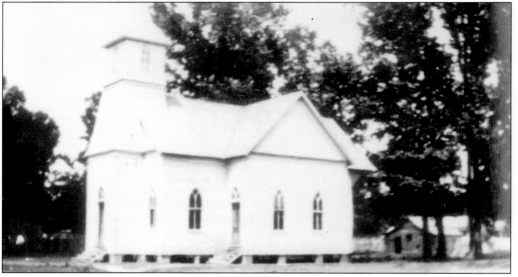

The First United Methodist Church of Plain Dealing was completed October 3, 1888, on a site donated by Mr. Zeigler. The first minister was not Methodist but a Presbyterian named McCarty. The first Methodist pastor was the Reverend E.B. Foust. In 1901, the old church building was torn down, and a new building, where the present church stands, was erected on a lot donated by J.O. Love.

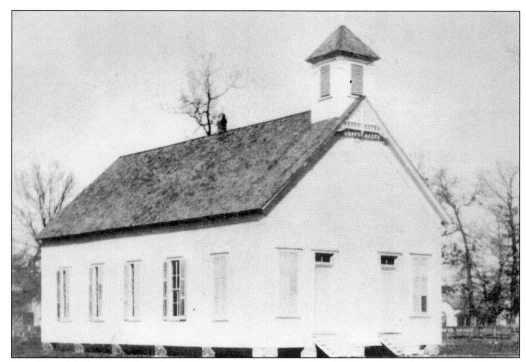

The First Methodist Church of Benton was completed in 1894 and was located on Simpson Street. The first marriage ceremony conducted there was for Luther Smith and Eva Larkin. The Epworth League was formed in Bossier Parish, February of 1900. Mrs. W.H. Scanland was the first president. It was formed in the Methodist church at Benton.

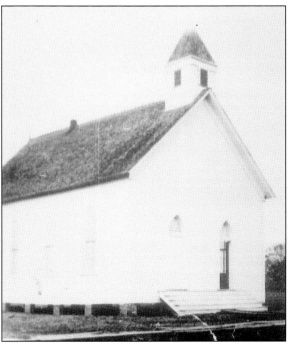

Photographed here is the First Presbyterian Church of Benton about 1900. From the earliest years of religion, the Methodist and Presbyterian churches met in the same church buildings, but on alternate weekends. About 1878, the Presbyterians divided themselves physically from the Methodists and claimed most of the church buildings, forcing the Methodists to build their own.

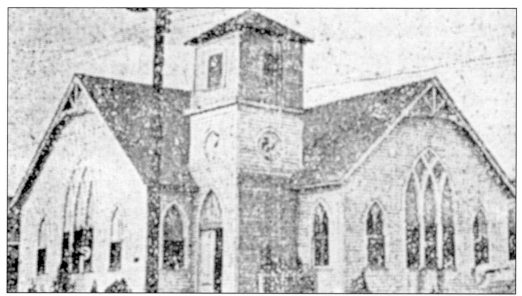

The First Baptist Church of Bossier City was formed on November 29, 1903, as the Ardis Memorial Baptist Church, with W.S. Penick, D.D., preaching the sermon. The lots for the building were donated by Dr. T.E. Schumpert, Colonel R.G. Pleasant, and W.B. McCormick. The original church building was given by Colonel Ardis. The membership by 1935 was nearly six hundred, and a newspaper article expounded, "The Ardis Memorial church has now become one of the big churches of the state."

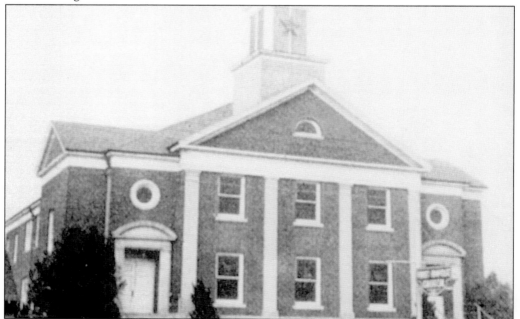

This brick First Baptist Church building was completed on February 1, 1939. It was designed by Peyton Bosworth, architect. By 1949, its membership had reached 1,795, residents and non-residents. More recently the church moved to 2810 East Texas, right in the middle of the Bossier Strip, where it has jokingly carried the title, "The Church A-Go-Go."

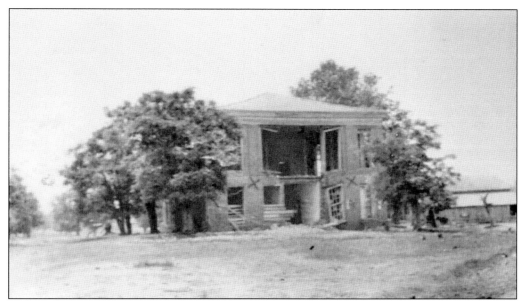

This pair of *c.* 1910 photographs show the old courthouse at Bellevue. It was built by Andrew Lawson and finished in September 1853. The building was a "brick courthouse, with a stone foundation, 60 feet long, and 44 feet in width . . ." Within a month of completion, on October 28, 1853, Mr. Lawson died, and his funeral was the first held at the courthouse he built.

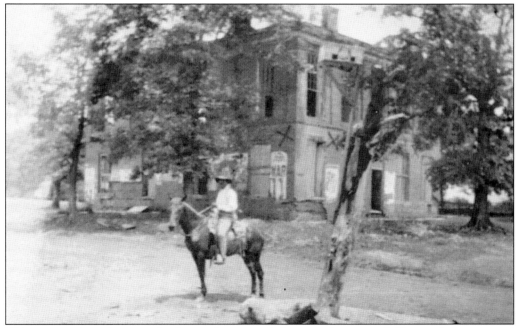

This companion photograph shows the rear of the courthouse at Bellevue that was used until November 11, 1890, when, amid controversy, the records were moved to Benton. The courthouse at Bellevue was neglected until May 4, 1910, when it was sold to Sam Lee, a Haughton farmer, for $25 for the materials. The house built from the materials was standing in 1999.

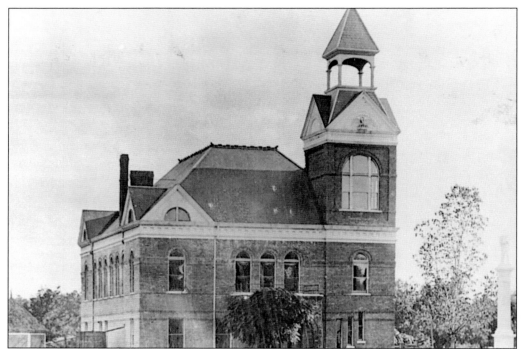

This c. 1915 picture is of the parish courthouse at Benton. It was built at a cost of $23,684 by Gibson and Oliff Construction. The building inspector and brick-maker was Seaborn H. Young. The lot had been donated to the parish for $1. This, the third parish courthouse, was the first at Benton. It was finished, and the celebration ball was given June 10, 1893.

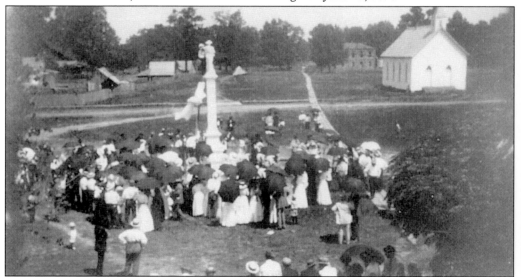

This photograph of the unveiling of the Confederate Statue at Benton was taken by John H. Allen of Plain Dealing on August 31, 1910. The statue was dedicated and the cornerstone laid by the Richard J. Hancock Chapter of the U.D.C. The statue is 20 feet tall and of Georgian Marble. It originally cost $1,250. The unveiling ceremony included dinner on the courthouse lawns.

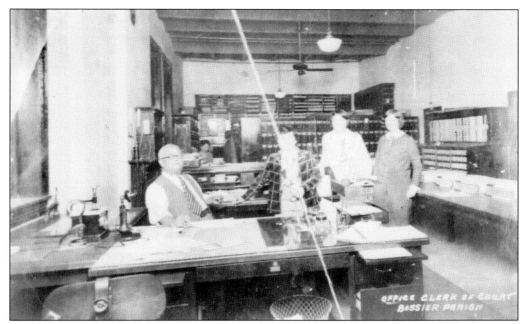

The interior of the old courthouse at Benton is best shown in this *c.* 1931 photograph. James M. Henderson, the clerk of court at that time, is seated. Grace Larkin, who would briefly succeed Henderson upon his death is wearing a dark coat. Gladys Thompson is standing next to Grace. The lady seated in the rear has never been identified.

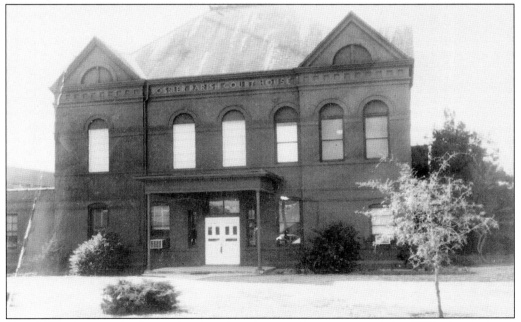

This 1952 photograph shows the fact that the steeple was removed in 1927. A telephone switchboard was added in 1937. Extensive remodeling was done to the exterior during March 1937 by N.B. Kelly. The typed indexes in the clerk of court's office were finished July 1, 1943. Air conditioning was added to the courthouse in 1954.

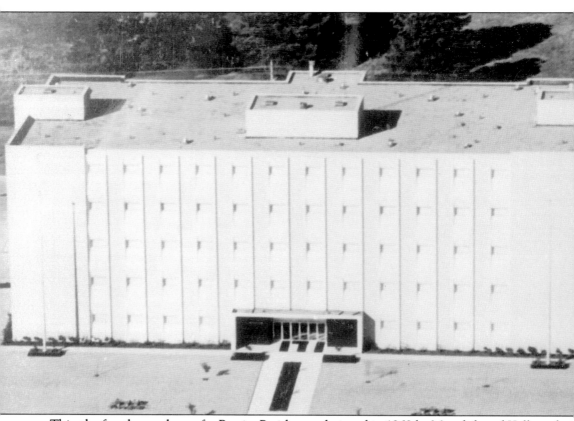

This, the fourth courthouse for Bossier Parish, was designed in 1969 by Meredith and Kelly and is about 110,000 square feet. The building cost about $2.8 million. The top floor contains the jail, and the other floors hold the parish offices. The building was built by the J.P. McMicbail Construction Company. Cornerstone ceremonies were on October 16, 1971. The building was dedicated on May 20, 1972. All efforts to move the courthouse to Bossier City have so far been resisted. Whenever the next courthouse is built, it is expected that Bossier City will push to have the courthouse placed there.

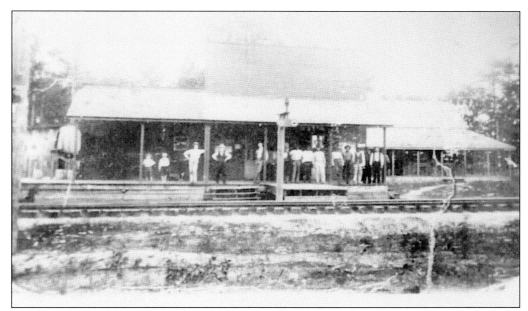

As this picture shows, the Alden Bridge commissary sat right next to the railroad tracks. The store was built about 1894. In an office near the store was a private wire (telephone) to Shreveport, which kept the business-like proprietors always in touch with the general markets, and the outside world.

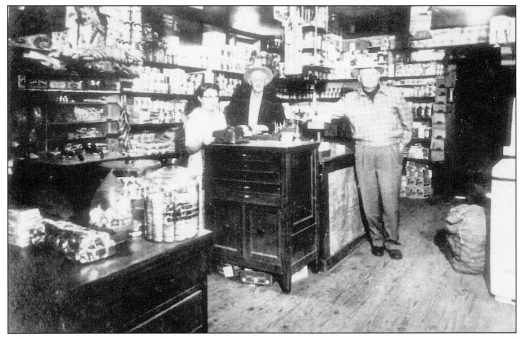

This is the interior of the Alden Bridge store as it looked in the early 1940s. Standing behind the counter are Mr. and Mrs. Hugh H. Strayhan. She was Lula Pirtle Stevens Strayhan, the mother of several Stevens boys and girls before their father died, when she married Mr. Hugh Strayhan. Joe H. Zeigler stands in front of the counter.

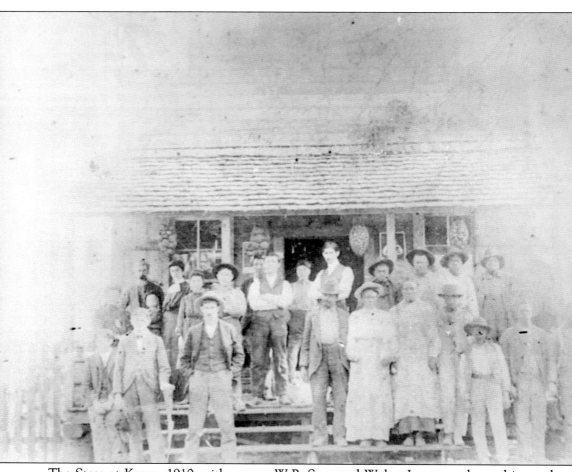

The Store at Koran, 1910, with owners W.B. Sapp and Walter Love, was located in south Bossier, below Haughton, and as this picture shows, had a thriving clientele. The whites on the front row are as follows: Tom Pollard, Clifford Palmer, and June Mabry. The second row consists of the following: Mrs. Walter Love, John Love, Bruce Sapp, Mrs. W.B. Sapp, Mary Lee Love, Mays Dees, W.B. Sapp, and Walter Love. In the third row are Matthew Stewart and Willie Dees. The African Americans are Hans Williams, Sarah Woodson, Henry Alexander, Willie Allen, Clint Smith, ? Woodson, Jake Bodenheimer, and Jesse Watson. (Some are not identified.)

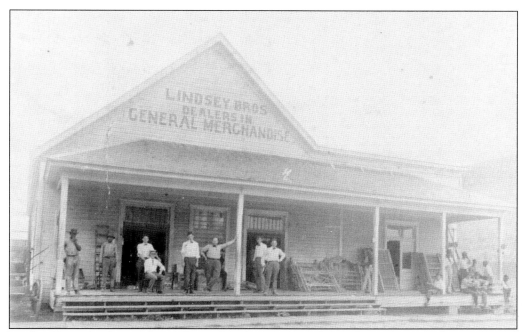

Lindsey Bros. Dealers in General Merchandise store was located in Benton, and was a typical small town, turn-of-the-century establishment complete with wrought-iron bed frames. The village of Benton was originally known as Ben's Town. When the railroad built its track through in 1888, the town became official and soon prospered, with the courthouse coming there in 1890.

The Ivan Store of Jasper Bunyun Whittington also served as the area post office. Bodcau Valley Railway Co. finished its private line running from Alden Bridge to Ivan, Louisiana, in 1904. Ivan Lake, which is just north of this store, was finished in 1957. In 1958, part of the old building was still standing, when it was torn down to make a new store.

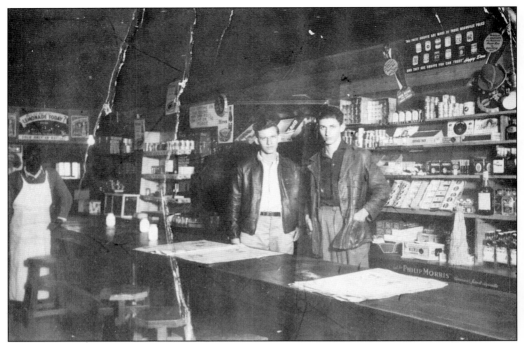

This pair of photographs shows the interior of the combination store and bar owned by brothers Willis and George Shipp shortly after the ending of World War Two. This photograph shows the store side. George and Willis stand behind the counter with a helper in the rear.

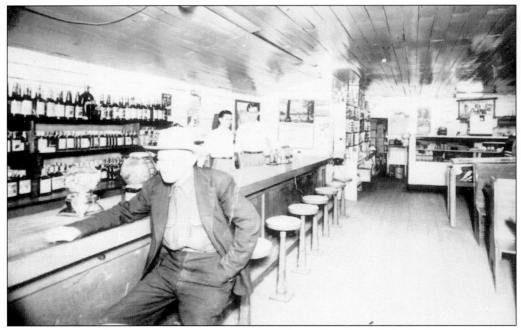

This companion photograph shows George and Willis standing behind the bar in the bar side of their combination store and bar in Plain Dealing, Louisiana. Their father is sitting in front.

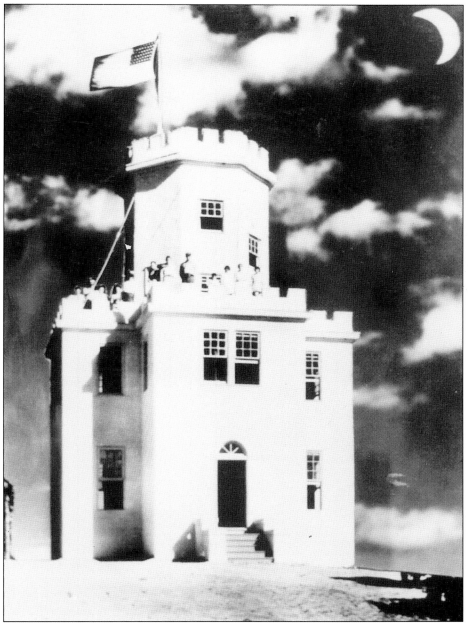

Giddens Castle was built by Tandy Key Giddens, a Shreveport businessman, in the 1920s as a tourist attraction and private getaway on top of Reeds Hills near the old town of Fillmore. It was used in the 1930s for early television experiments; broadcasts were being made from atop its tower to nearby Shreveport. This photograph is unique, as it is of the castle tower, but has been doctored with an American flag, false skyline, clouds, and a crescent moon. The wheels and feet of the workman can been seen at the bottom. The finished postcard would show neither the wheels, the people atop the castle, nor the moon. The castle was a lot larger than it appears and had a large showroom attached to the rear of it. It burned in the 1930s, and it is now the location of Hilltop Recreational Center.

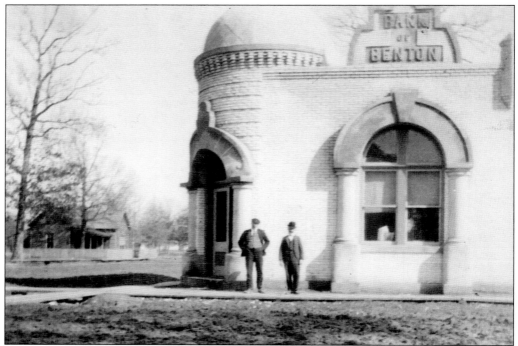

Shown here is the Bank of Benton as it appeared when it was first built. At the time Benton had no paved roads and only had wooden sidewalks. The Bank of Benton began on April 29, 1904, and was chartered for business in May of 1904 with $10,000 in capital. It opened for business September 1, 1904, with deposits totaling $1,386.25 that day.

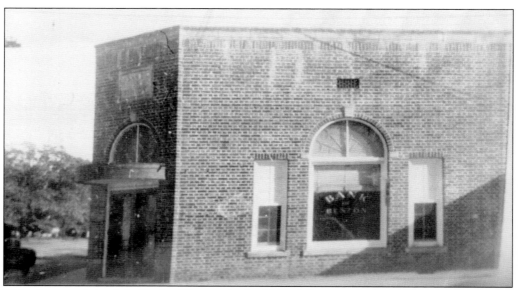

This photograph is of the Bank of Benton in the 1940s. The upper building was used until 1926, at which time it was replaced with this construction. It was extensively remodeled in the 1950s and still stands. This building was used until June 8, 1961, when the Bank of Benton moved to its new location to the south of this one.

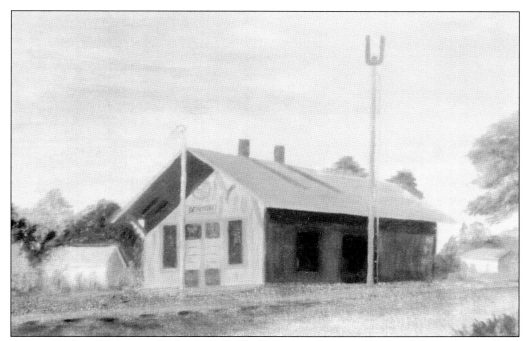

Benton Railroad Depot was built when the St. Louis-Southwestern Railroad (later Cotton Belt) Railway was completed through Benton in 1888. It became the centerpiece for "New" Benton. By 1889, the town boasted a hotel, a livery stable, one store, three dwellings, a depot, and a two-story section house. The depot was closed in 1963.

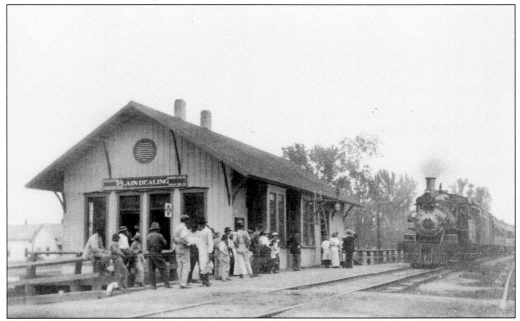

The Plain Dealing railroad depot was also built in 1888. This c. 1910 picture shows that the arrival of the train was a community affair, as can be seen by the many citizens gathered here. This picture was taken by John H. Allen, camera artist and early Plain Dealing postmaster.

The Poole, Louisiana railroad depot was built about 1896 by the Louisiana Red River railroad. It was used until the 1940s when it was moved a few hundred feet to this site in Poole. Efforts are currently underway to move the house, which is still owned by descendants of the Poole family, to a more easily protected site and restore it.

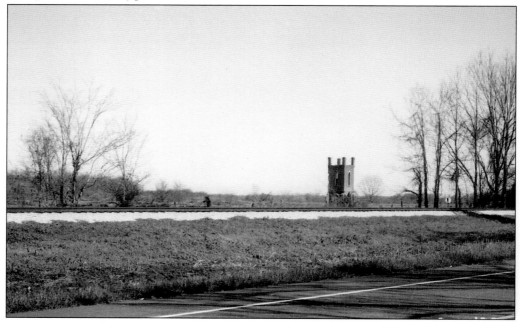

Long the source of many rumors and legends, there isn't much left of the old Taylortown church tower in southern Bossier Parish. It was actually built in 1907 by the Methodists, but it soon fell into disuse, and after efforts by a Catholic church to use it, it began to crumble and was abandoned by the 1950s.

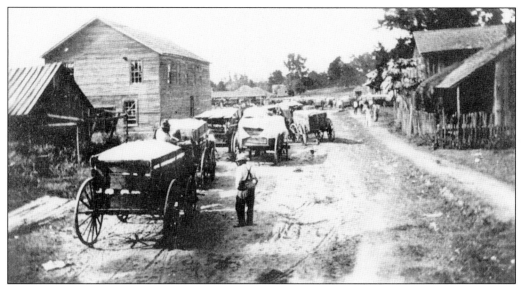

Wagons gather at the Bell and Sentell Cotton Gin on Lynch Street in Plain Dealing. The gins would run night and day, ginning cotton. It was said that some farmers would have to sleep in their wagons to keep their place in line. Cotton would remain a mainstay of some farmers until the 1990s, when very few cotton fields would remain in Bossier.

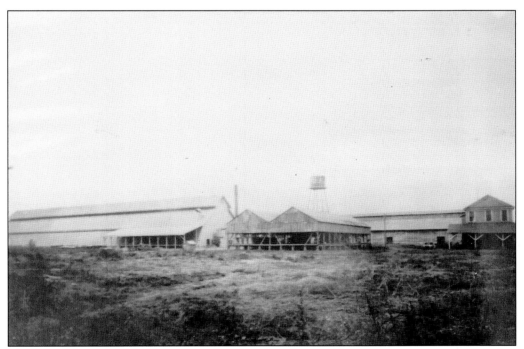

Hamilton Cotton Oil Mill, on Hamilton Road in Bossier City, was a monstrous affair that processed cotton seed into items including cooking oil and bulk for cattle feed. The oil was even used to make early plastics. The mill was owned by William E. Hamilton, a leading citizen of Shreveport who happened to be born in Bossier.

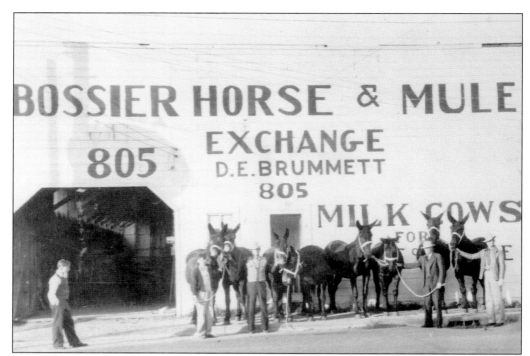

Loy Beene, of the Beene Plantation, is shown with four pairs of mules newly purchased from the Bossier Horse and Mule Exchange. Tractors would not become an integral part of the plantation until a few years later. The Beene Plantation was owned by Haynesville Mercantile, which still owns large tracts of land in north Bossier City.

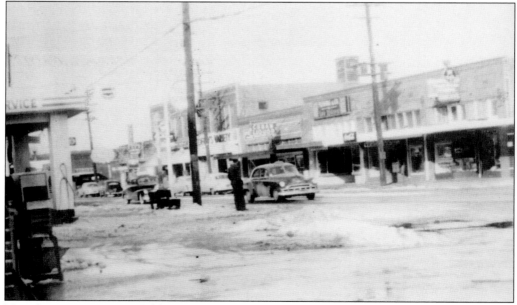

Very few pictures exist of old Bossier City, but this one taken in the late 1950s shows a recent snowstorm. We are looking west down Barksdale Boulevard. The buildings then contained Cuban Liquor, a variety store, a service station, and the newspaper office.

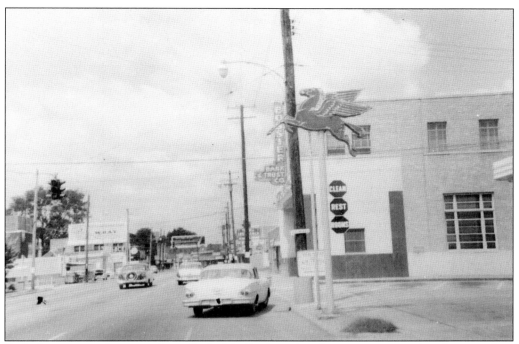

By looking at another view down Barksdale Boulevard and comparing it to the photograph at the bottom of this page, one can see the drastic change in the skyline in the last few years. What once contained banks and insurance companies now contains print shops, massage parlors, and a newspaper office.

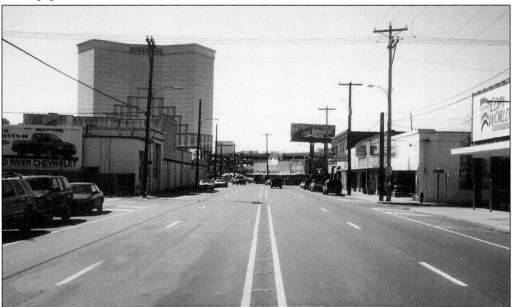

This 1999 picture of the same block shows how the mammoth Horseshoe Hotel dominates the skyline. Bossier City is now home to some three gaming boats including the Horseshoe Hotel. The other two are the Casino Magic and Isle of Capri, which are just south of this area.

This Bossier City town hall was dedicated May 19, 1927, with Mayor Tom Hickman presiding. The cornerstone laying had been performed November 13, 1926, which included putting copies of the *Bossier Banner* and *Bossier City News* in an iron box. The hall represented an investment of $50,000. The building fronted on Cain Street, and in the building was the city office, city court, auditorium, jail, and fire station, the latter two departments were fireproof.

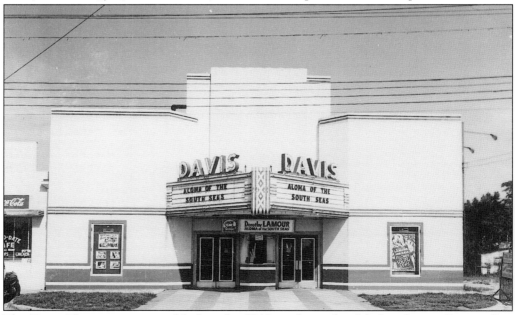

The Davis Theatre was opened before the 1940s and was the delight of many Bossier City children. It remained open until the 1960s. The building is still standing and is now the Loridan's Building on Barksdale Boulevard.

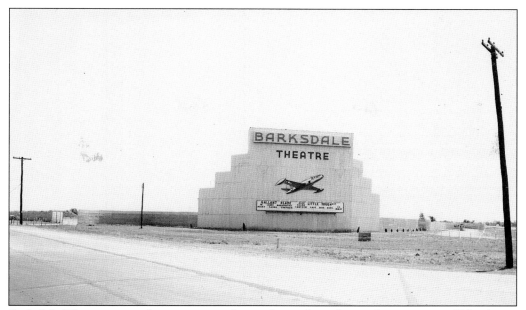

Barksdale Theatre was a drive-in movie theater located on the southeast corner of Northgate and Old Minden Road. It derived its name from Barksdale Air Force Base, which was right down the road and supplied many of its customers.

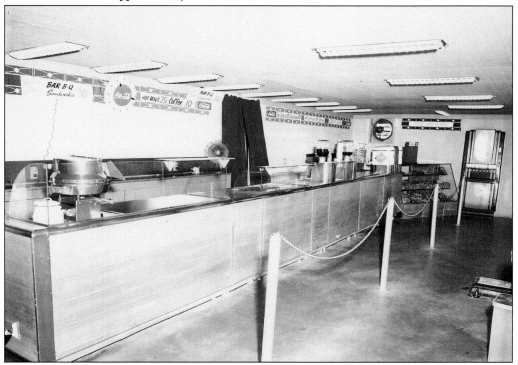

The interior of the snack shop at Barksdale Theater proudly displays its prices. Cokes, snow-cones, and coffee were 10¢, hot dogs 25¢, and Bar-B-Q sandwiches 30¢. These photographs were taken in August of 1951.

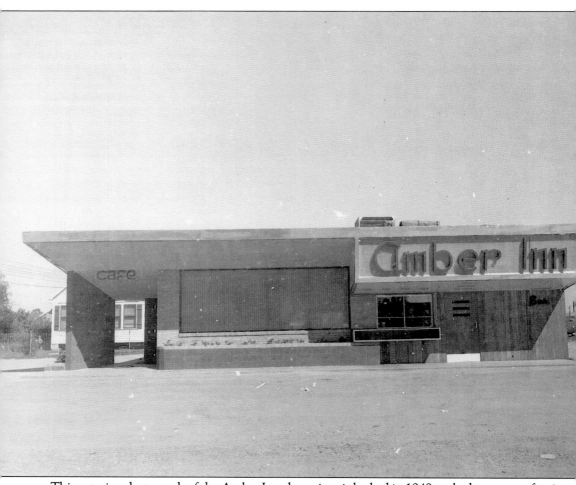

This exterior photograph of the Amber Inn shows it as it looked in 1949, only three years after it was opened by P.B. "Buddy" Lombardino and Carl Maniscalco. By the time of this photograph, Buddy's brother Charley Lombardino had bought out Carl Maniscalco in October of 1946, and the business was owned by the two Lombardino brothers. It was considered the place to eat by many people in Bossier City and Parish.

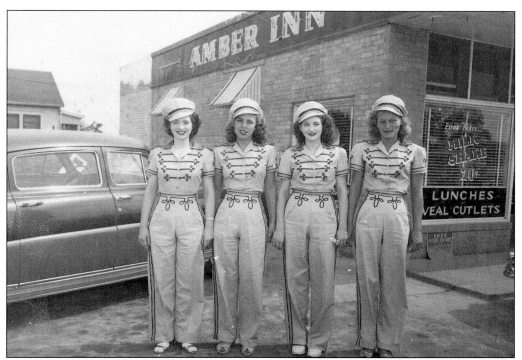

To "fit in with the times," the Amber Inn used car hops to deliver the food to the patrons who preferred to sit in the car and dine. The car hops, left to right are as follows: Verna McDaniel, Merle Searcy, Betty Brookings, and Barbara ?.

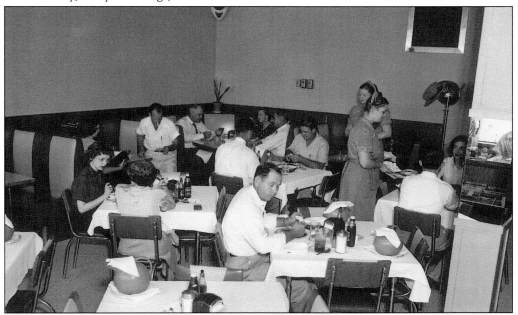

The Amber Inn also offered indoor seating for the less hurried guests. After 32 years in business, both of the Lombardino brothers decided to retire in 1978 and thus closed the business. For the next 11 years, the building contained a China Inn, and is now a gentlemen's club.

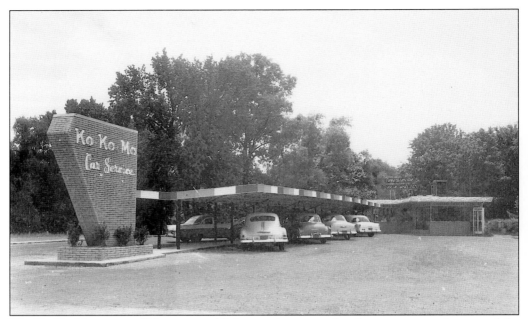

The Ko-Ko-Mo was a well-known establishment that catered to the teenagers and young adults of Bossier. Owned by the Bates family, it was named during the time when other names such as Kickapoo were being popularized. The name meant nothing in particular, but was just cute. This Ko-Ko-Mo was located at the corner of Shed and Benton Roads.

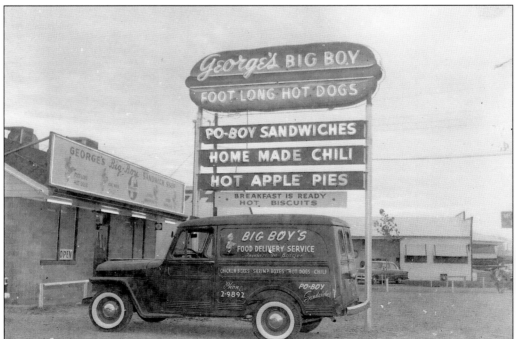

George's Big Boy featured foot-long hot dogs, po-boy sandwiches, chili, pies, and delivery service. It was owned by none other than George Dement, now Bossier City's illustrious mayor. This photograph was taken during the early 1950s.

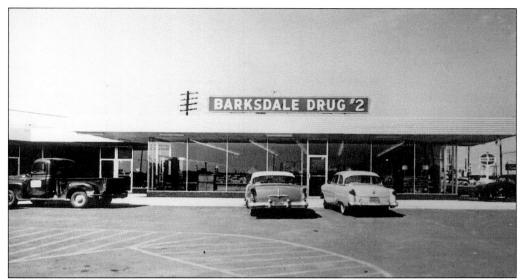

Barksdale Drug Number 2 was a popular place to have your prescriptions filled in the 1950s when this photograph was taken. The building is still standing at the corner of Barksdale Boulevard and Old Minden Road near the heart of Bossier Shopping Center. It is still a drugstore.

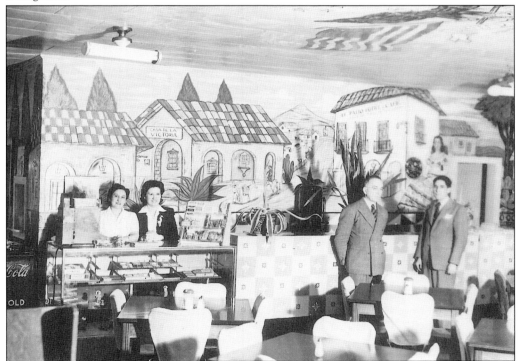

This 1945 picture shows Senor Frank Cueller at the El Patio Restaurant at 1845 East Texas in Bossier City. The manager's name was Mrs. Molly P. Polloch. It was next to Harry's BBQ. A few years later, Frank Cueller would merge with his brother's restaurants to create the now famous El Chico's restaurants.

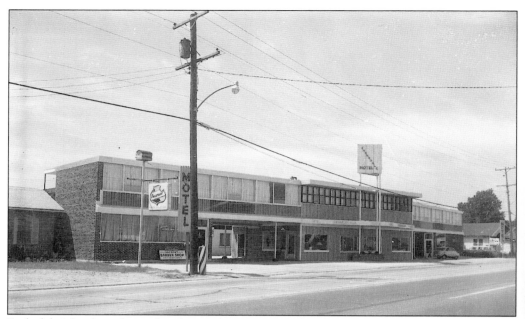

Barksdale Motel was located at the southwest corner of Airline Drive and Barksdale Boulevard, and was built to cater for the visitors coming and going to Barksdale AFB. It was owned by Gus J. and Mrs. Cecile C. Burandt. It was finally closed and torn down in the 1990s.

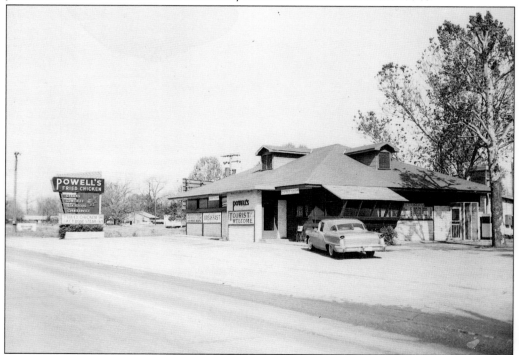

Powells Restaurant was a longtime, favorite Bossier City eatery, owned by James and Emma Powell. It was located at 1701 East Texas, "in the curve." The building is still standing, but is now a used car lot.

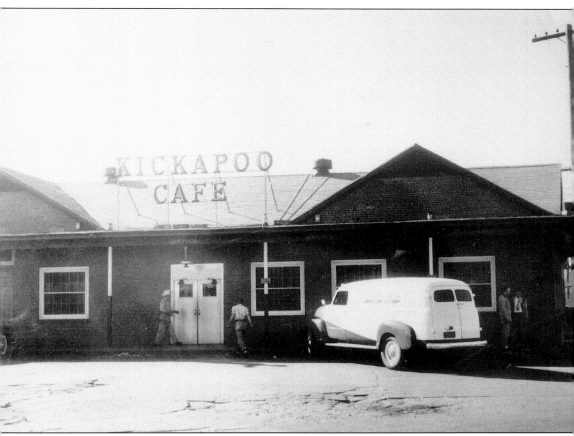

This photograph shows the Kickapoo Restaurant, which was located at the northwest corner of Benton Road and East Texas at the time when Bossier City stopped at Benton Road. It was considered by many as *the* place to eat. Open most hours of the day, the restaurant was where one could either enjoy dinner, supper, or even an early morning breakfast after spending the "night on the Bossier Strip." For years it sat on the very edge of the city limits, within the city but out of the control of Bossier City police officers.

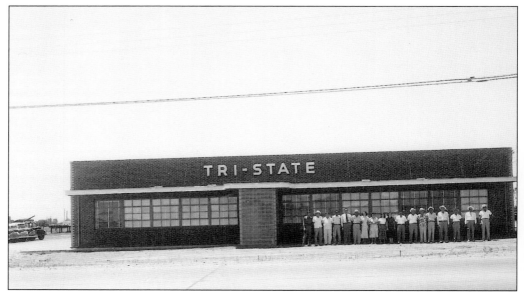

TriState Oil Tool Industry came to Bossier City in 1945. This building was their pride and joy and was finished May 1, 1951. This photograph featured their employees in front of their new building on East Texas Avenue. The building is still standing, but is part of Bolinger Lumber Company.

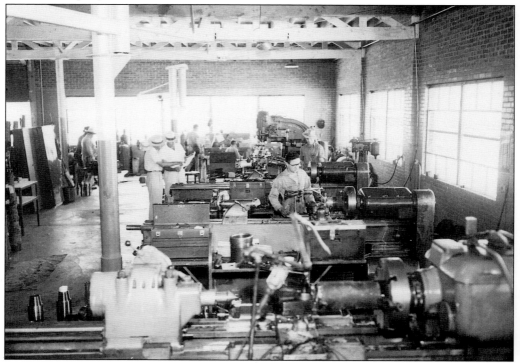

TriState Oil Tool Industry was established December 1, 1945, by G.H. Burnham of Longview, with seven employees. This picture was taken June 1, 1951. By then, Earl P. Sawyer of Arkansas was a co-owner. They would produce many oil field "fishing" tools before closing in the 1990s.

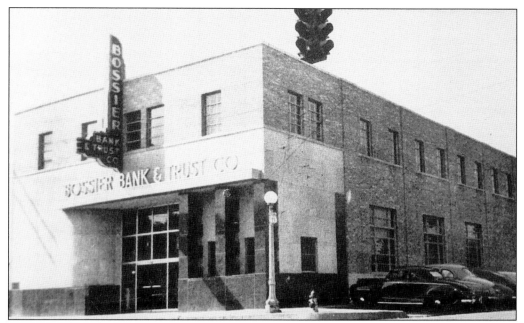

Bossier Bank and Trust was established in 1923 by Dr. Shea Edward Prince as the Bossier State Bank with a capital stock of $25,000. After Prince's death in 1941, Volney Voss Whittington became president. This new structure, designed by architect J. Cheshire Peyton and built by W.A. McMichael, was finished at a cost of $250,000.

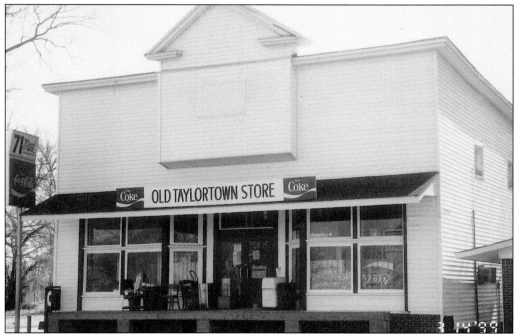

The Old Taylortown Store is the oldest continuously used store building in Bossier Parish. Built about 1892 by William D. Mercer, it still operates on Highway 71 south of Bossier City. It was named after the Taylor Wholesale Company, where they received most of the goods.

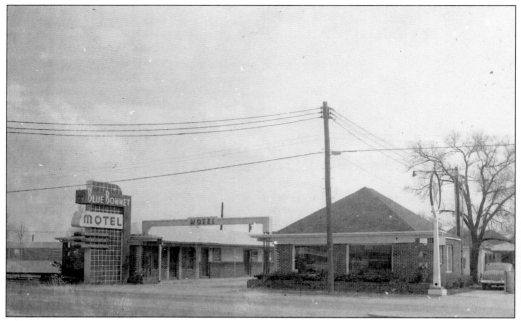

The Blue Bonnet Motel is one of the few motels, or motor courts as they were called in the early days, that still exists. It supplied a decent room to travelers and tourists coming to see Bossier's infamous strip.

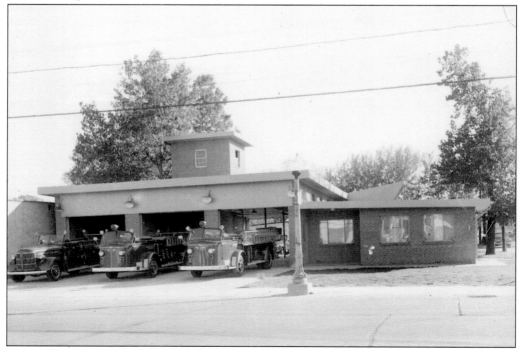

This 1952 photograph shows the fire station built just next to old City Hall on Barksdale Boulevard, in old downtown Bossier City. The station before this one was actually inside the City Hall building. This fire station is still being used.

Barksdale Field, now Barksdale Air Force Base, was opened on February 2, 1933, as a gift from the City of Shreveport to the United States government. For years it was the largest air base in the world. It was named after Lieutenant Eugene Hoy Barksdale, who was killed August 11, 1926, while test piloting an Air Corps plane at Dayton, Ohio. It had been built in Bossier because an earlier site near Cross Lake had been turned down by the government. Shreveport quickly chose this as their new site and it was accepted. It took approximately five years to get the base to a condition where it could be dedicated.

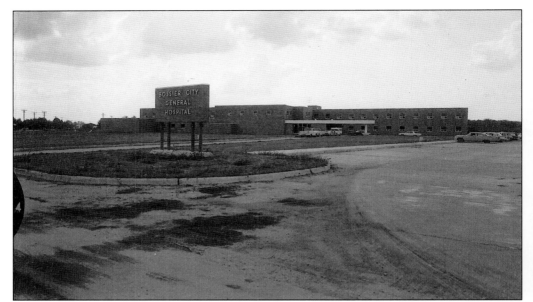

Bossier City General Hospital, now Bossier Medical Center, was officially dedicated on September 11, 1966. It cost $2.5 million and was designed by Tom Meredith of Bossier City and was built by McInnis Bros. of Minden. It employed 167 people, all but four of them lived in Bossier City. It was built from a $2.3-million bond approved by Bossier City voters in 1963.

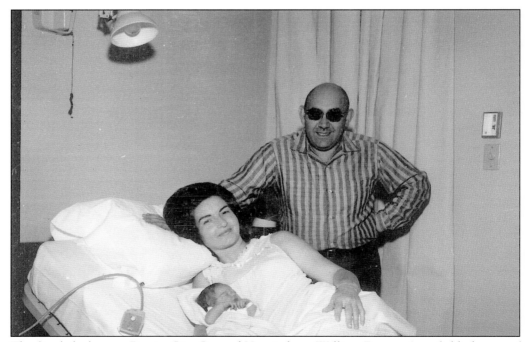

The first baby born at Bossier City General Hospital was William Earnest Axenfield, the son of Mr. and Mrs. Myron Axenfield of 4222 Stuart Street, Bossier City. He was a 6 pound, 9 ounce baby, born at 10:40 p.m. Mr. Myron "Mike" Axenfield ran the Turf Lounge in Bossier City for 13 years. He now lives in South Texas.

Four

PLACES AND EVENTS

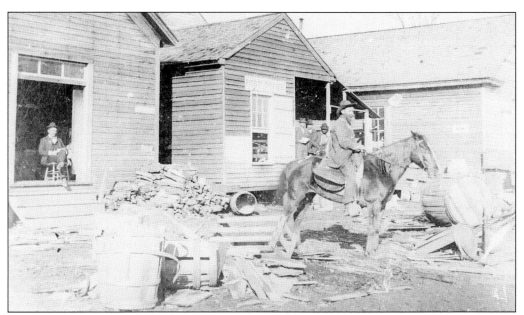

This is the only known nineteenth-century photograph of a mail delivery person in Bossier Parish. John J. Roberson, who is seated on the horse, was originally hired as a mail contractor to carry mail from Red Land to Carterville. Soon, thereafter, he became postmaster of Carterville on January 2, 1895.

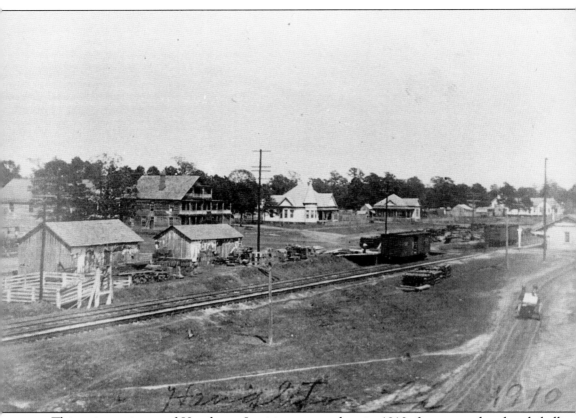

This unique picture of Haughton, Louisiana, was taken in 1910, from atop the church bell tower. A wagon loaded with a bale of cotton proceeds to the railroad depot. The three-story building in the center is the Crume Hotel. At the far left is the store of T.H. Lawrence, which was the last surviving building, until 1997, when it was dismantled. The white house on the right would burn in the 1950s. Behind it is the Edwards' home, which would burn in the 1990s. Fire has been a strong enemy of Bossier Parish's early homes and towns.

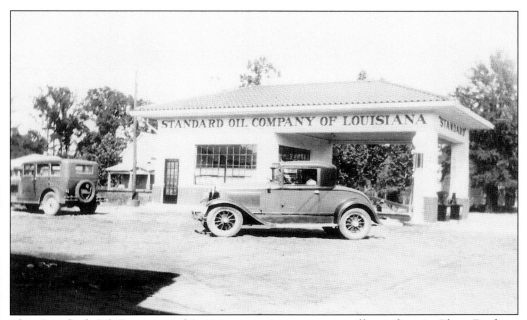

This Standard Oil Company of Louisiana service station is still standing in Plain Dealing, although the cars pictured are probably long since gone. The first cars arrived in Bossier Parish in the early 1910s, and from then on, an entire industry and road system had to be developed. Early Bossier roads were not designed for thin rubber tires.

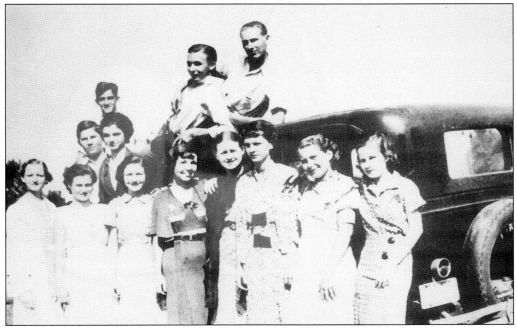

A group of south Bossier Parish residents attended Elm Grove School. Mathilde Gatlin McLelland, Mamie Johnson Pilkinton, and Dorothy Gamble are in the bottom row. Those on top of the car are, left to right, as follows: B.H. "Blackie" Snyder, Elizabeth Brown Connell, and Joseph Elston.

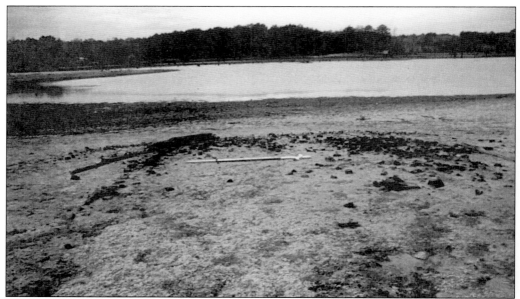

The lowering of Lake Bistineau allowed area archaeologists and historians a chance to view something unseen in years. The Bistineau, or Kings Salt works, existed prior to the Civil War and for years afterwards in the area of South Bossier and Webster Parishes, known as Salt Works, Louisiana. Brine water was pumped to the surface, boiled in kettles, and reduced to dry salt.

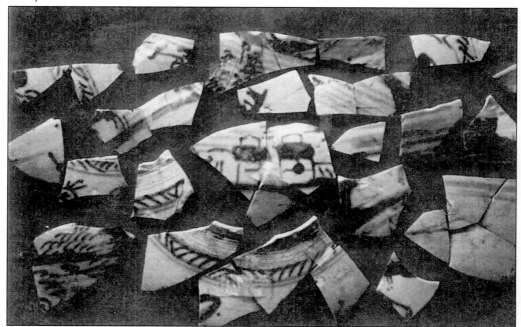

Among the artifacts found at the Salt Works excavation were axes and other metal implements needed in the mining of salt. This unique pottery bowl was found at the Salt Works excavation. These never before published photographs show a small sample of the industry that once thrived at the site.

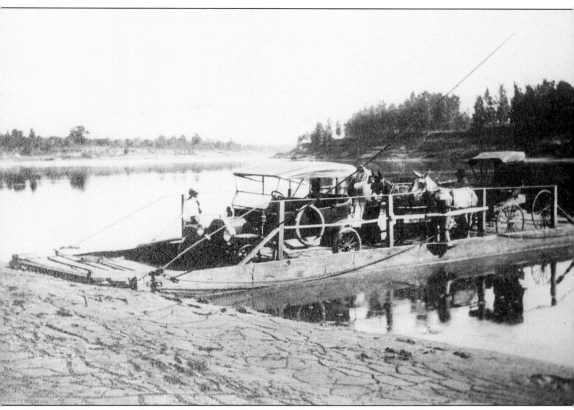

Millers Bluff Ferry was located about 1 mile north of where Louisiana Highway 2 crosses the Red River, west of Plain Dealing going to Hosston. This picture was taken by John H. Allen, of Plain Dealing, about 1910. The Miller Bluff Bridge between Plain Dealing and Hosston was opened June 20, 1955. It was about a mile below the old ferry. This is only one of two known photographs of ferries in Bossier Parish.

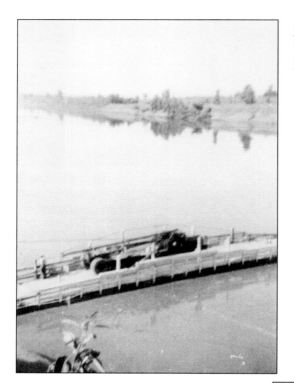

Just northwest of Benton, Louisiana, was the Cedar Bluffs Ferry, which took even the largest trucks across the Red River. The ferryboat was powered by an outboard engine.

Another photograph of the Cedar Bluffs Ferry shows sisters-in-law Theresa Stevens and Dolly Strayhan posing by the family-owned ferry. The ferry was closed a few years later, and now crossing the river is done either at Millers Bluff Bridge to the north, or Bossier City to the south. The employee who worked the ferry was only remembered as "Sam."

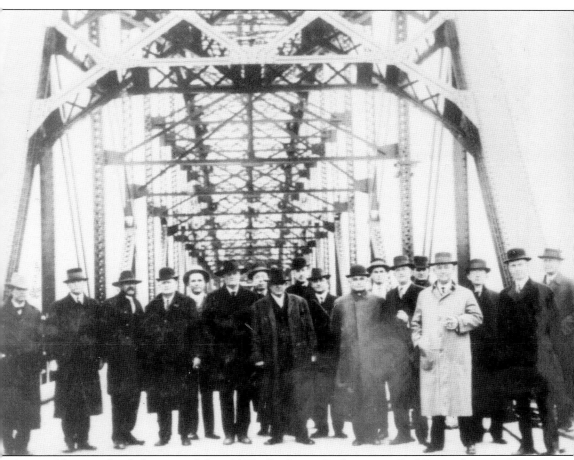

Pictured here is the dedication of the old Traffic Street Bridge across Red River, January 11, 1915. The bridge was built as a joint effort by the City of Shreveport and the Bossier Parish Police Jury at a cost of $350,000. It was the first bridge across the Red River built exclusively for traffic—thus its name. It was torn down in the 1960s after the completion of Interstate 20 through Shreveport and Bossier. Left to right are the following, listed by number from the left: 1. J.G. McDade, Bossier Parish Police Jury (BPPJ); 2. Robert Whittington, BPPJ; 3. Nat Stewart, BPPJ; 6. J.T. McDade, president of BPPJ; 7. J.C. Logan; 11. Claude Rives, Shreveport accountant and ex-councilman; 12. Mr. Ward; 15. Shreveport mayor S.H. Dickinson; 16. Lewell C. Butler, Shreveport City Council (SCC); 17. George Thurber, (SCC); and 18. George Wilson, (SCC). The rest are unknown.

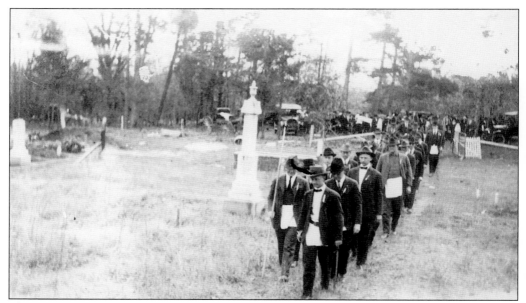

This Masonic funeral procession was for the interment of Senator William Benton Boggs in 1922. He was buried in the Plain Dealing Cemetery next to his first wife, Estelle Swindle Boggs.

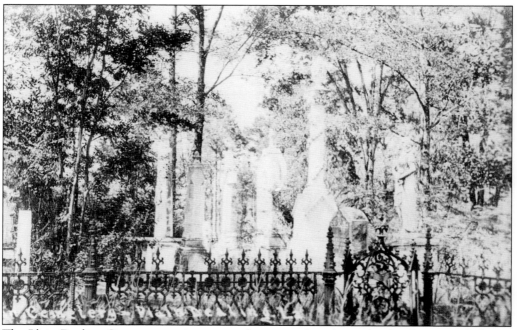

The Plain Dealing Cemetery got its start as the private burial spot for the George Oglethorpe Gilmer and James Blair Gilmer family of Plain Dealing and Collinsburgh. This photograph shows how their family plot looked in 1910. Their descendants deeded the cemetery to the Town of Plain Dealing. The iron fence is no longer there.

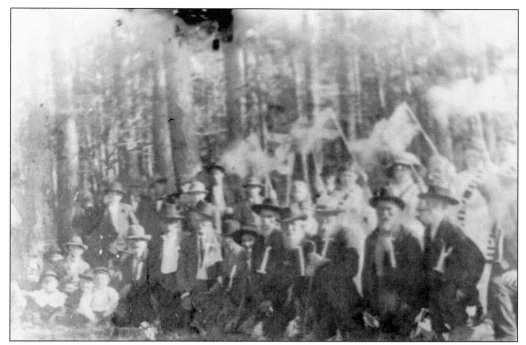

This is one of the last photographs taken of the Confederate veterans of Bossier Parish. It was taken in Plain Dealing during a reunion. Behind the veterans are Sons of the Confederate Veterans, an organization dedicated to preserving their heritage.

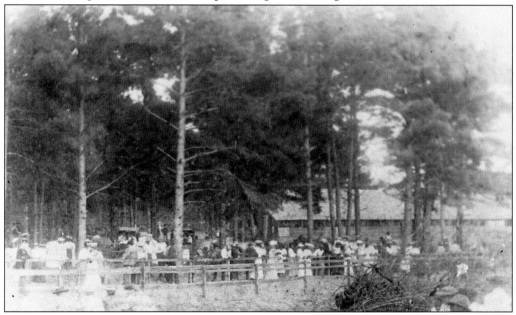

The Bossier Parish Fair was begun in Plain Dealing in 1907. The admission was 25¢ for adults; 15¢ for children between the ages of 12 and 15; 35¢ for horse and rider; 50¢ for vehicle and driver; and 50¢ for two horse vehicle and driver—a season ticket for a public hack (taxi) was $3.00. The fair was moved to Bossier City in the 1930s and shortly thereafter discontinued.

Abney Scanland is shown cleaning the type of the *Bossier Banner* newspaper around 1910, when his father was still the owner/publisher. Abney would later take over production of the paper, when his father fell ill and was unable to work. He continued the paper until the 1950s.

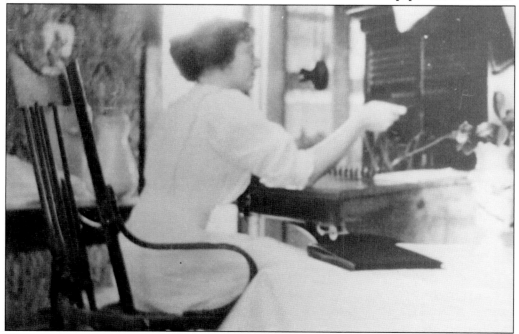

This photograph is of the telephone operator at Plain Dealing. Plain Dealing's phone system was originally a private affair which has now grown to a national business known as Century Telephone.

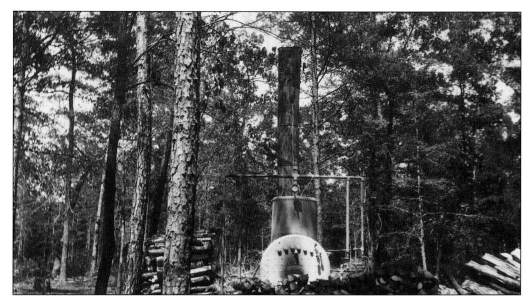

This steam boiler utilized the heat from burning wood to produce steam for various reasons. This particular steam boiler was used in a sawmill operation in northern Bossier Parish.

Today's children would not believe how big the logs were that were once dragged through the forest. While animals could do much of the work, it was also possible for a single man to attach a log to the bottom of this log drag, which as it rolled would pick up the log and drag it along the ground.

This is the last known cotton press in Bossier Parish. Owned by the McDade brothers of Fillmore, it existed until the 1950s. Raw cotton would be put into the press, whereupon the large arms would be turned and the cotton pressed into a bale, ready for shipment to the cotton gin.

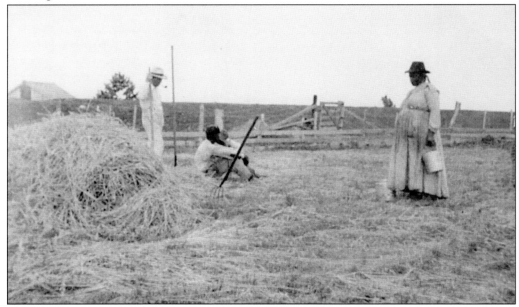

This picture from around 1910 shows how hay-raking was once performed manually. These unidentified farm hands are hand raking hay on the farm of Alex R. Thompson, who once served as the sheriff of Bossier Parish.

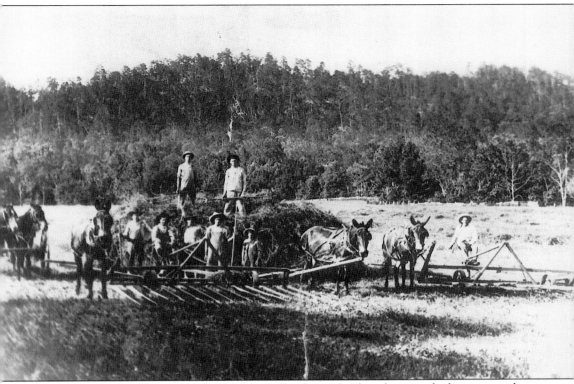

Within a few years, farm techniques had drastically changed. This photograph shows an early hay-raking device that used mules as its primary energy source. The men had to walk along side the apparatus and keep the hay fed into it. Although still quite labor intensive, it would reduce the work of weeks into the work of only days. The location of this photograph in Bossier has never been determined.

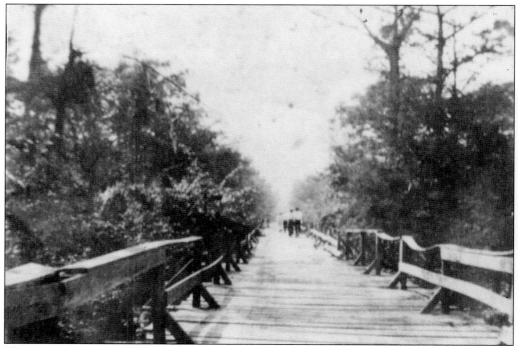

This 1910 picture of the bridge across Bodcau Bayou, on the road from Benton to Bellevue, shows the crudeness of many early bridges. It was a single lane wide, and drivers had to be courteous and wait for the other wagon to clear the bridge so they would not meet in the middle. Fights did occur, when drivers were in a hurry.

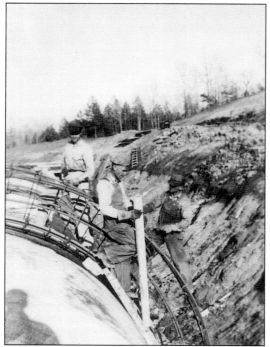

By the 1940s flooding in the Red Chute and Bossier City areas was so large a problem that the damming of Bodcau Bayou became necessary to control the rising waters. Here Delmas and Frank Floyd work as ironworkers on the Bodcau Dam project. Unlike all other dams in Bossier, this created a floodgate, not a true lake.

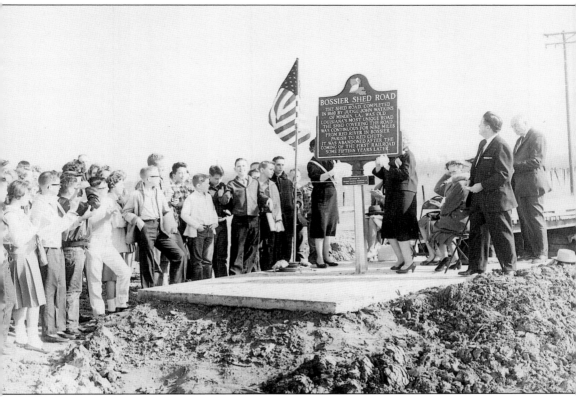

From 1872 to 1888, Bossier Parish had the only known roof-covered dirt-floored roadway in America. It ran from the Red Chute hills to north of Bossier City, about 9 miles. In 1961, this marker was dedicated to commemorate that road and its contribution to the area. Boyd Montgomery and Volney Voss Whittington perform the ceremony. Boyd represented the Bossier Parish Police Jury and V.V. Whittington was a state representative from Bossier Parish.

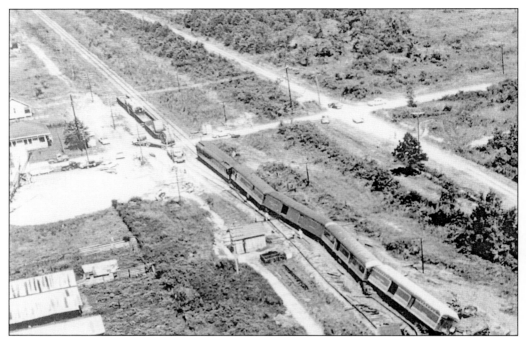

This 1959 train wreck occurred near Bodcau Station, east of Bossier City. Arthur Oliver of Shreveport was instantly killed when he drove a Braswell Cement truck into the path of the Illinois Central passenger and mail train. The entire train of eight cars and diesel engine was derailed and some 200 yards of track destroyed.

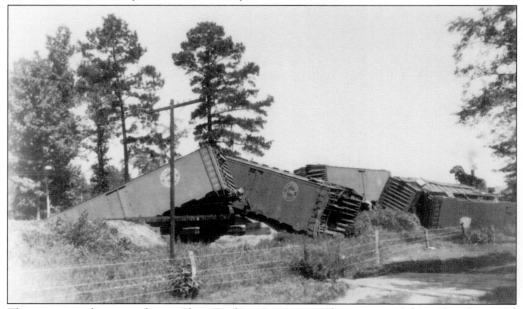

This train wreck occurred near Plain Dealing, Louisiana. The coming of the railroad in 1888 produced a newfound horror for area residents, as the speeding trains would often kill livestock and sometimes people. These wrecks and the destroyed track had to be replaced in as short a time as possible to make way for the next trains.

Pictured here is the interior of the Plain Dealing Post Office, c. 1912. This photograph was taken by John H. Allen, who served as postmaster for Plain Dealing from 1913 until 1924. The young lady has never been identified.

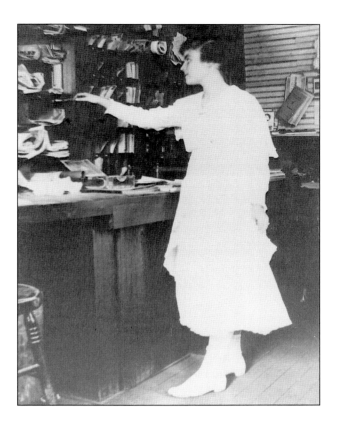

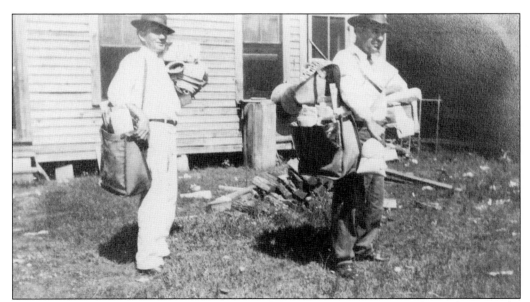

Home delivery, or rural free delivery, of mail did not start in Bossier Parish until 1907. The postal carriers are delivering mail in Plain Dealing about 1910. The bags on their shoulders are saddlebags and are being put onto their horses.

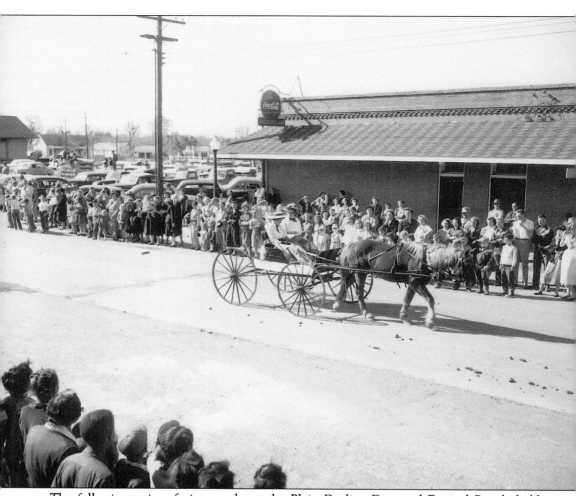

The following series of pictures shows the Plain Dealing Dogwood Festival Parade held on March 25, 1953. The parade is still held in the spring of every year and celebrates the blooming of the beautiful dogwood trees along Dogwood Drive, north of Plain Dealing. The celebration, now well over 50 years old, maintains a stringent family celebration style. The event includes a preset drive along what is deemed the most beautiful stretch of road in Bossier Parish. Every year a committee chooses the most scenic route according to the proliferation of dogwood blooms.

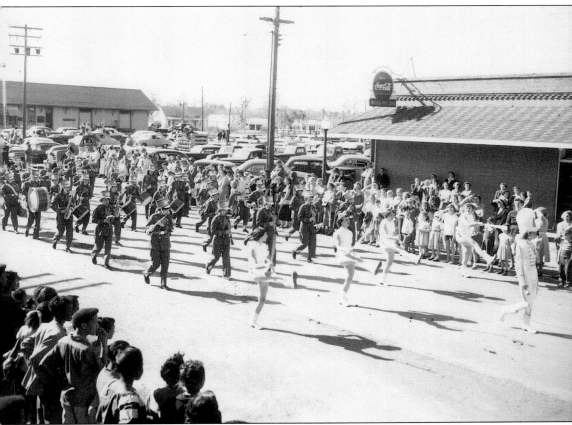

The Dogwood Parade of 1953 was attended by none other than Governor and Mrs. Robert F. Kennon. Mrs. Kennon's maiden name was Eugenia Sentell, and she had grown up just south of Plain Dealing on the Collinsburgh Road. The governor was originally from Minden, although at this time he was living in Baton Rouge in the Governor's Mansion. They were entertained by several marching bands, including the band from Barksdale Air Force.

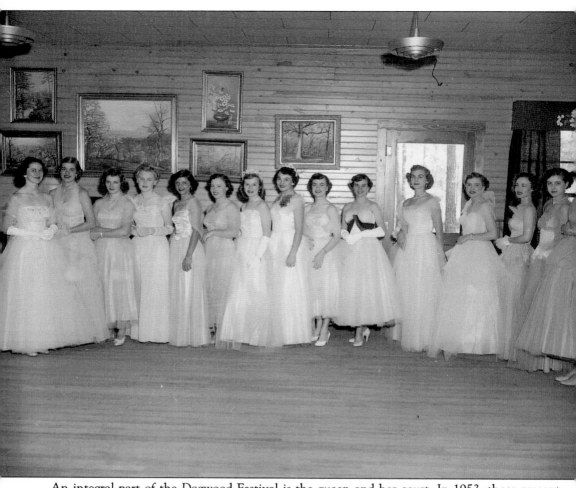

An integral part of the Dogwood Festival is the queen and her court. In 1953, those present were Miss Julia Ann Burford, 1953 queen; Miss Marilyn Barnett, 1952 queen; Betty Seabolt; Marilyn Horneman; Peggy Turnley; Rita Vernon; Lila Gore; Joyce Winn; Joyce Hardcastle; Madeline Horneman; LaNell Winham; Mireace Rodgers; and Celia Morgan.

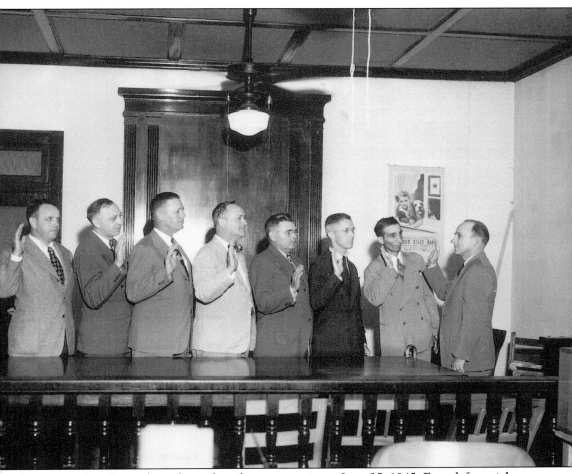

The Bossier City Council are shown here being sworn in on June 25, 1945. From left to right, they are as follows: Dwight Laughlin, J.D. "Dutch" Fenton, Ray Festervan, Mayor Hoffman L. "Hoff" Fuller, H.N. Bowman, L. Paul Dyson, Danny Meizel, and Bossier Parish Clerk of Court, A.J. "Bruce" Broussard. They had to deal with the ending of World War II and the growth that all other cities, especially one located next to an air force base, had to deal with at the conclusion of the war.

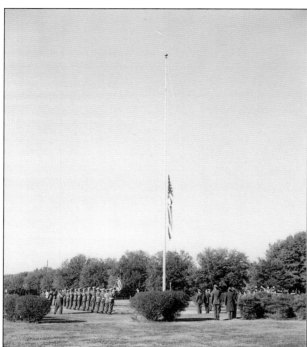

Some schoolchildren of today think nothing of the 50 stars they salute on the American flag. This photograph shows the first raising of the then new 50-star flag at Barksdale AFB, on November 15, 1960. The flag has now remained unchanged for more than 38 years.

For years rumors have existed that Barksdale AFB had a near devastating accident with an H- bomb on June 10, 1955. Although they have always denied the rumor, on June 11, 1955, Barksdale had its first H-bomb test evacuation. This photograph shows one air force family during the test.

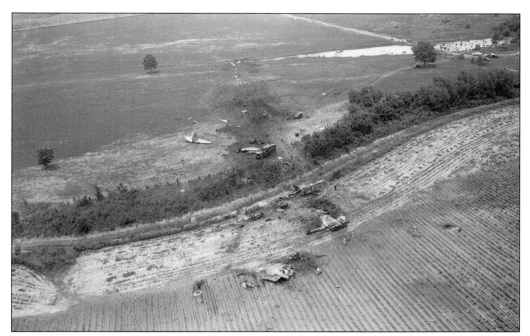

On Friday, June 10, 1949, a B-45 four-jet bomber crashed in a field near what is now Louisiana Downs racetrack. This aerial photograph shows the extent of the crash. The plane's crew was Captain Ralph L. Smith, Captain Milton O. Costello, and James L. Louden.

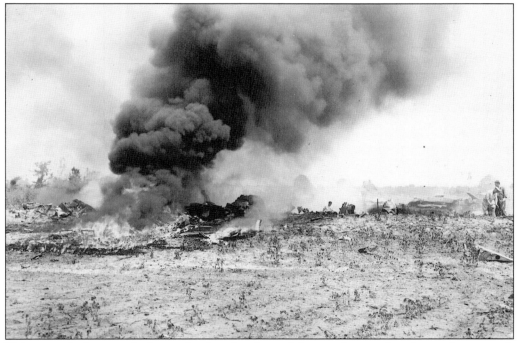

This ground photograph shows the fire that burned for two hours after the crash occurred. Costello and Smith were killed instantly, and Louden miraculously survived the crash. Captain Louden was found near the crash scene by Sam and Ned Touchstone.

The next two photographs will give you an idea of how much Bossier City has changed since the 1920s. This is looking west on Broadway Street. The young lady is dressed for "tacky day" at school. She died giving birth to a child a few years later.

In the photograph is George Chambers Jr. as a young child on Barksdale Boulevard in the 1920s. Behind him on the left is the Barksdale Hotel, near where Carefree Janitorial is today.

Five

THE BOSSIER STRIP

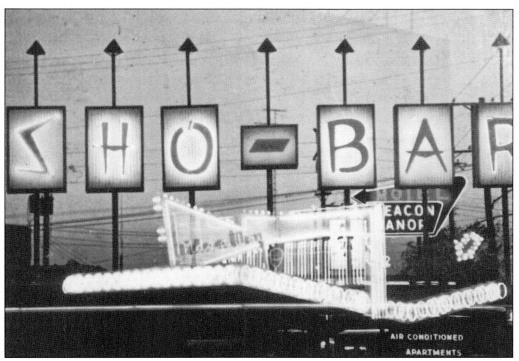

This triple exposure photograph shows some of the spectacular neon signs of the (in)famous Bossier Strip. The collage gives some idea of the glamour that the Strip tried to portray. But the bright lights often hid dark secrets. Of the three signs included, only the Beacon Manor Hotel still stands. The Bossier Strip ran from downtown Bossier City to, and actually beyond, the Bossier Parish limits. What started about 1930, with the opening of Highway 80 across north Louisiana as a direct route from Georgia to California, would spawn generations of growth and ridicule for Bossier.

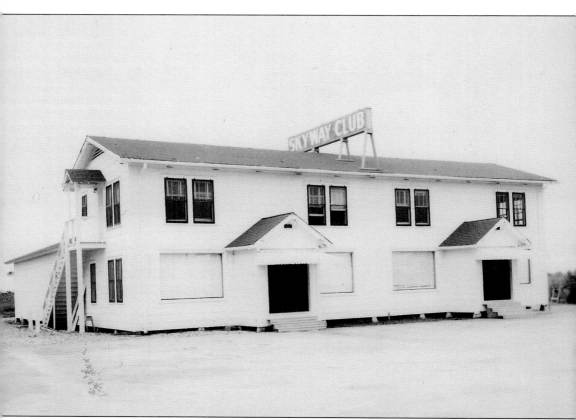

The Skyway Club of Bossier Strip fame shows the rudimentary start of the strip. This photograph and the next one were taken in 1948. It would be the next decade before neon lights would dominate East Texas Street, Barksdale Boulevard, and Old Minden Road. The glitz and glamour of neon lights would start to make the strip shine, beckoning travelers from near and far. Many of these photographs have never been published before.

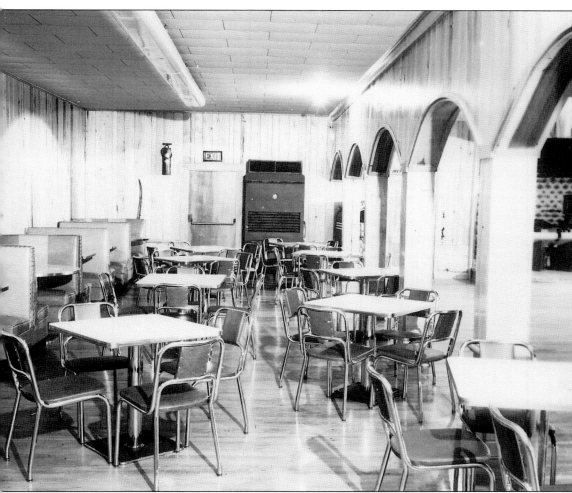

This interior shot of the Skyway Club gives an idea of the services offered by the club. The dining room is visible, and just to the right was the show stage. The bar was to the far right. Very little has been written about the strip and some deem it unworthy to even mention. But, it was an integral part of Bossier's past and actually fueled decades of growth for the city and parish.

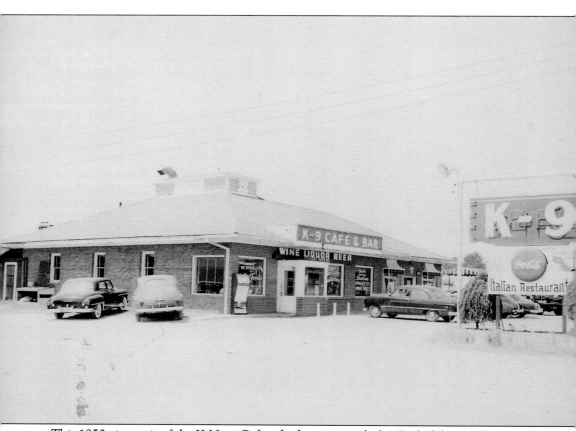

This 1950 picture is of the K-Nine Cafe, which was named after Barksdale Air Force Base's use of canines for military patrols. The combination cafe/bar/liquor store was owned by Aaron Beam and stood at 1802–1804 Barksdale Boulevard. Blaine M. Crawford was listed as the manager in 1950. It was later owned by Joe Armenio. The mirror on the corner of the building is still owned by Joe's son, Tony Armenio, of Louisiana Neon Signs.

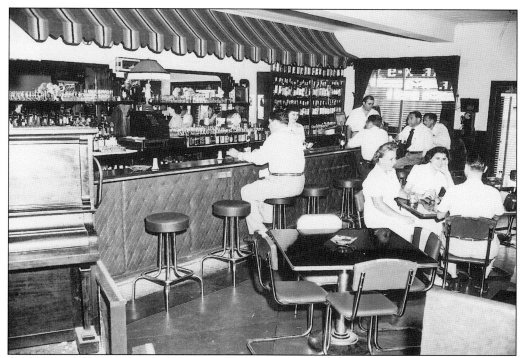

This interior shot of the K-Nine Cafe shows the bar side of the building. Second from right is Joe Armenio. Behind the bar is Aaron Beam (the owner) and seated at the bar, by himself, is Wes Hardin. Seated at the table with his back to the photographer is Henry Vines.

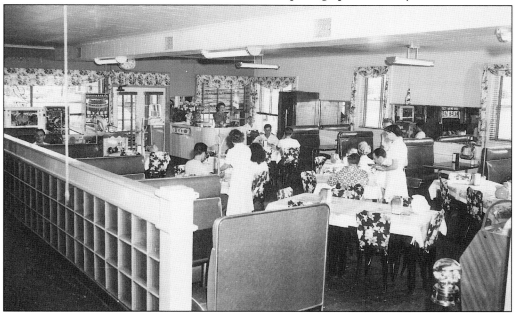

This interior shot of the K-Nine Cafe shows the cafe side of the building. Behind the counter is Mrs. White, longtime cashier for the establishment. In the back right corner are Tony, Joey, and Sammie Armenio.

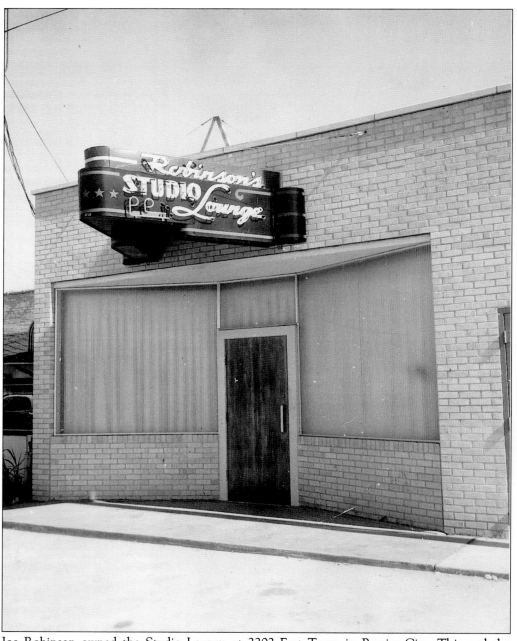

Joe Robinson owned the Studio Lounge at 2202 East Texas in Bossier City. This and the following photograph show the exterior and interior well. The building still stands today, just east of the intersection of Benton and Texas, behind the Vacuum Cleaner Hospital. For years it was known as the Longbranch Saloon.

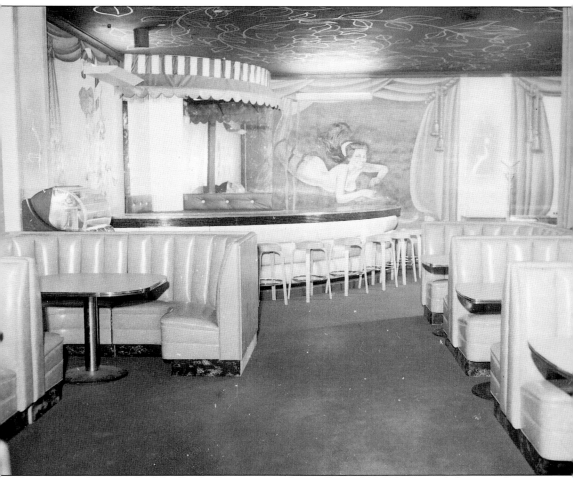

The interior photograph of the Studio Lounge was taken in June of 1950 by *Journal* photographer Jack Barham. The mural of the nude mermaid was sure to cause remarks by the patrons of the lounge. The jukebox and the dance floor in the corner provided entertainment.

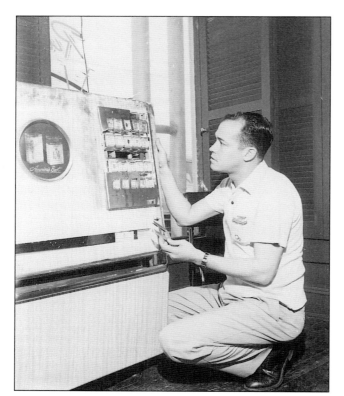

Ruben White, as in Ruben White Industrial Park, owned the Hurricane Bar at 127 East Texas. In this photograph taken in 1957, he is surveying damage caused by a vandal. The building was finally torn down in 1998.

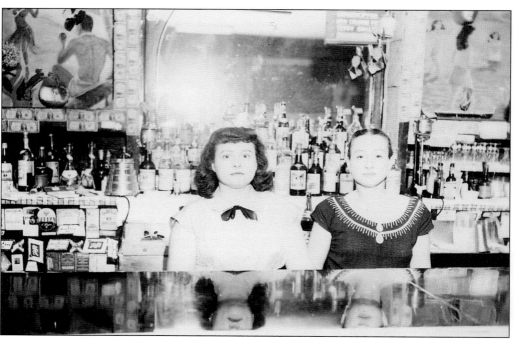

This is an interior picture of the Hurricane Bar in 1952. Again, photographs of nude women grace the walls. The women working behind the bar have never been identified.

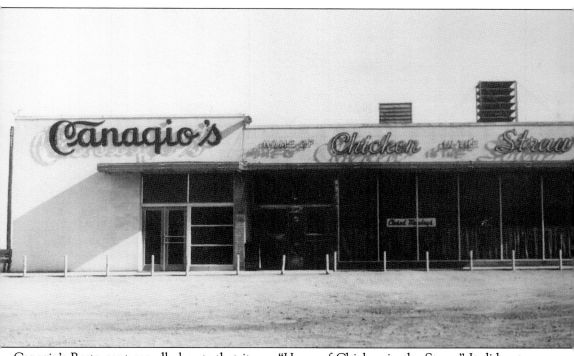

Canagio's Restaurant proudly boasts that it was "Home of Chicken in the Straw." It did not remain open long, as soon thereafter the site was a restaurant. It was located in what is now the Gold Mine Pawn, at 2010 East Texas.

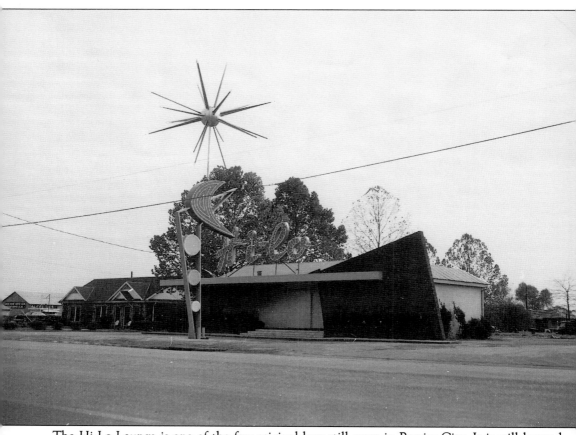

The Hi-Lo Lounge is one of the few original bars still open in Bossier City. It is still located at the corner of Hamilton Road and East Texas Avenue. The bar got its name when it took over the sign of the Holiday Lounge. The only name they could make from the old neon sign was Hi-Lo.

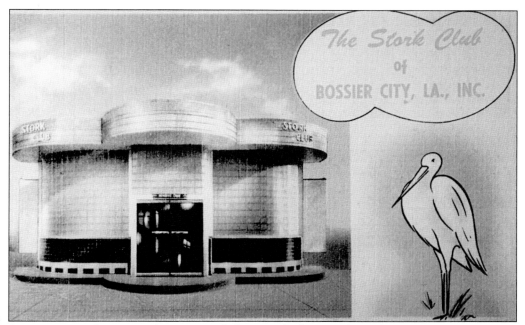

By comparing the postcard on top and the actual photograph on bottom, one can see the difference between advertisement and reality. The Stork Supper Club was a combination eatery, strip bar, and lounge in three separate parts of the same building.

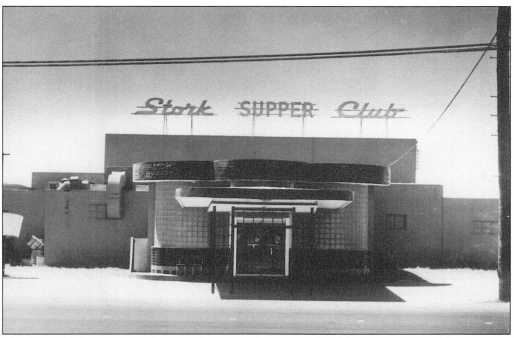

The Stork Club was owned by Joe Robinson and was considered by many as one of the premiere spots on the Bossier Strip. Years later, like many of the businesses on the Bossier Strip, it mysteriously burned.

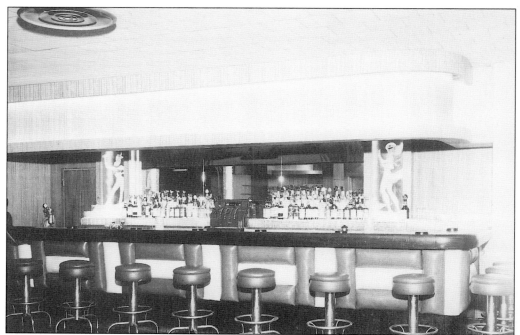

The bar of the Stork Club served patrons the drinks of their choice. Chrome, Naugahyde, and linoleum were the decorations of the day. Sex was the theme.

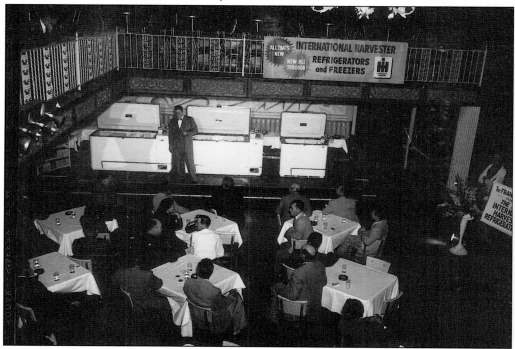

This Frank Lyons Company exhibit featuring 1953 International Harvester refrigerators shows how business and pleasure were combined by having these business trade shows at the Stork Club. And no, the girls did not come out of the refrigerators!

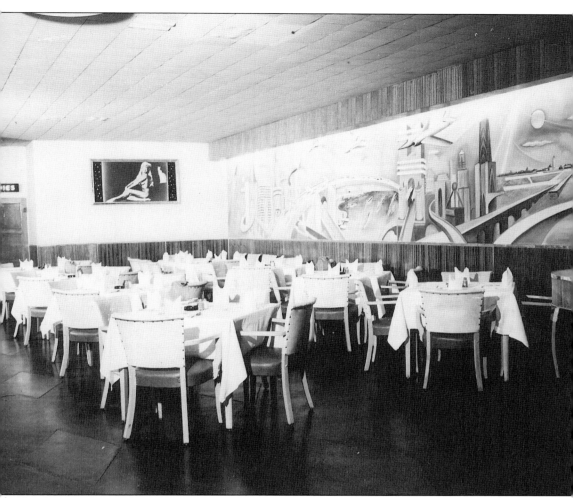

The dining area of the Stork Supper Club was well arranged and featured a hand-painted futuristic mural on the wall. But the nude painting on the rear wall featured what was on most patrons minds.

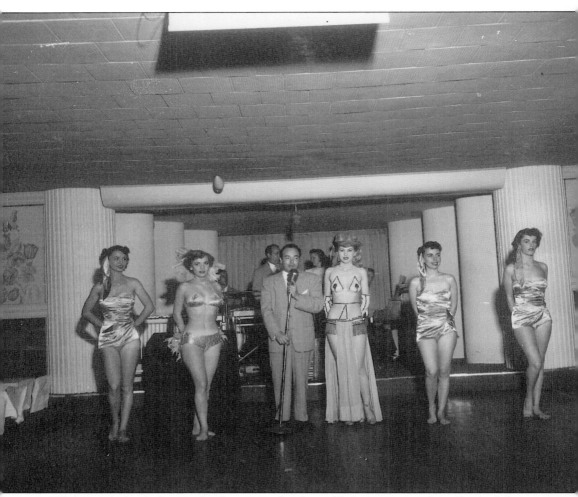

What was most on the minds of patrons of such establishments were the girls. And there were plenty. This 1950 photograph of the stage act at the Stork Club shows how much entertainment the girls were willing to offer. What worried officers more was what went on in the back rooms of these establishments.

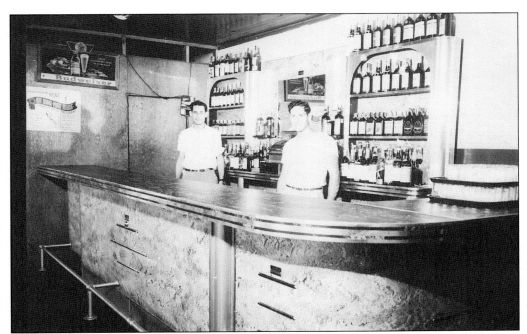

Sammy's Bar and Cafe featured a personal touch. The owner, Sammy Gugliuzza, and his brother Tony stand ready to serve patrons. The bar later became known as the Twilight Lounge. Sam himself died in a knife stabbing. His murderer was never prosecuted.

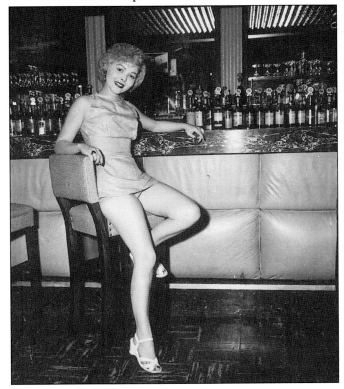

This 1956 picture of a "working girl" at the Twilight Lounge leaves little to the imagination as to what she had to offer. Today, she is probably someone's grandmother. The Bossier Strip required a concerted effort by the District Attorney's office, the Sheriff's office, and Bossier City officials to "clean up."

ACKNOWLEDGMENTS

Professional recognition must be extended to Laura, Domenica, and Glenda at the Louisiana State University-Shreveport, Noel Memorial Library Archives, and to Louis, Shanna, Vicki, Nita, and Phyliss at the newly created Bossier Parish Historical Center. I owe a sincere thank you to the many individuals who loaned me their photographs for this book. My thanks to Tony Armenio, Mrs. Bennie Baker-Bourqueois, Edmund Bator, Flo Whittington Bigby, Eric Brock, Joan Carraway, George "Willie" Chambers Jr., Danette Hudson Clark, Beulah Allen Findley, Delmas Floyd, Mrs. Homer Flynn, Eugene Groves, D.A. Horton Jr., David Jeane, Mrs. Jolly, Martha Ree Jones, G.T. Kellogg, Stan McCallon, John Miller, Mrs. Martha Mitchell, Mrs. Eileen Nabors, Susan Shipp Neal, Kay Noska, Bill O'Daniel, Keith O'Kelley, Emma Patillo, Harry Stevens, Ford Stinson Jr., Sandra Whittington Upshaw, Rachel Wright, and Neill Yarborough Jr. My apologies for those I left out. It is both a pleasure and a thrill to find and present these photographs to the public in general. I hope you enjoy this book as much as I have enjoyed creating it.